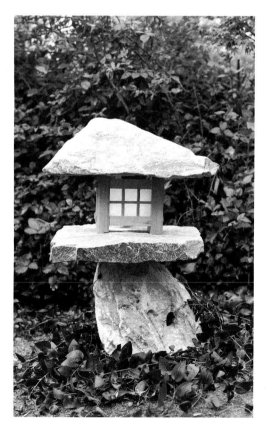

including photographs by Jeffrey Westman
illustrations by Donald Dean Illustration/Design

KODANSHA INTERNATIONAL
Tokyo • New York • London

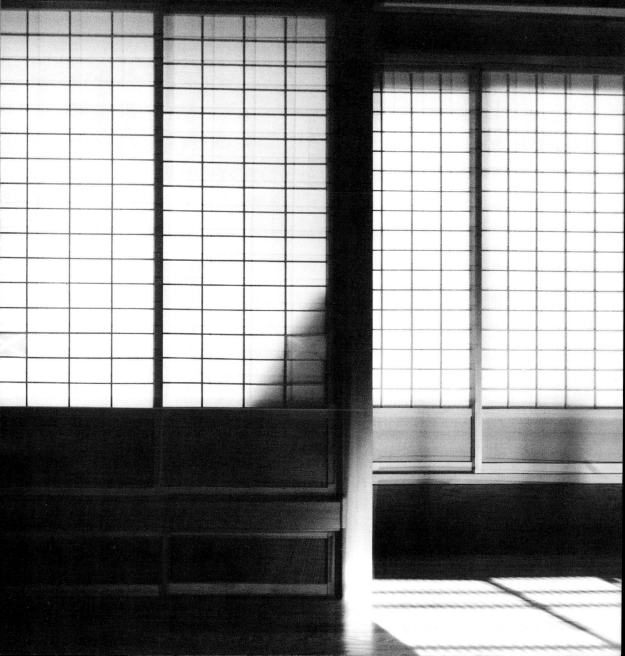

6 PREFACE

ONE 9 **DESIGNING WITH SPACE AND LIGHT**

TWO 17 **WOOD, PAPER, AND TOOLS**

18 Traditional Aesthetics, Modern Applications
20 About Wood
22 Wood Varieties
24 Paper and Paper Substitutes
26 Installations
28 About Japanese Tools
30 Layout Tools
31 Chisels
35 Planes
38 Saws
40 Polishing Stones

THREE 45 **MAKING A SIMPLE SHOJI SCREEN**

46 Planning
48 Deriving Overall Measurements
48 How Much Wood?
50 Milling, Squaring, and Inspecting the Lumber
51 Preparing the Frame

54 Preparing the Lattice
58 Assembly
59 Completing the Shoji
60 Putting on the Face

FOUR **63** **PROJECTS FOR THE HOME**

70 Lattice Patterns
74 Stationary Panels
76 Liner Boxes
78 Hipboards
79 Sandwich Shoji
80 Glass-Panel Shoji
81 Closets, Cabinets
82 Shoji with Movable Panels
84 Valances, Hanging Screens
86 Ceiling Fixtures, Skylights
87 Decorative Wall Boxes
88 Lanterns
90 Freestanding Screens
91 Outdoor Shoji
92 Joinery Options

93 **APPENDIX**

94 Security
94 Books on Japanese Tools and Woodworking
95 Paper Vendors
95 Tool Vendors
96 Index

Preface

The first woodworking experience I remember as a child was standing eye-level with the worktable where my grandfather was making a wooden wagon wheel. I watched as he meticulously shaped each piece and spoke with a spoke-shave. After the parts were all assembled, he and my father heated the metal rim in a circle fire built on the ground in front of the family blacksmith shop. Then they took the red-hot rim, expanded by the heat, and pounded it onto the wooden wheel. As the rim cooled, it shrank and squeezed the joints of the parts into the center hub to hold them in position.

This was in the early 1950s. Even at that time I sensed that this kind of work was from a past that was rapidly fading. Today, the craft of making metal-rimmed wooden wheels by hand is even rarer than the wagons and carriages that use them. I feel uniquely fortunate to have grown up in this kind of environment, and to have its experience and perspective.

Some ten years ago in California, after a stint in graduate school, I happened to see a traditionally trained Japanese *daiku* (carpenter) named Makoto Imai demonstrating how Japanese tools and joinery are used. His satisfaction with his work was basic and genuine. The ease and confidence with which he handled his tools was clear and was most contagious to me and to others who saw him. Here, I thought, was a tradition like the one I had grown up with.

In recent years, other Japanese carpenters have come to the West. A handful of Americans have gone to Japan to study tools and woodworking techniques, while other Americans are finding their own way in the United States. What these people have in common is a deep appreciation for handwork and the conviction that craftsmanship follows naturally from diligent practice. All of these woodworkers have consciously sought to hybridize Japanese and Western techniques and designs for their American clients.

While dealing with traditional construction methods, this book reflects the attitude that shoji deserve to be seen in a design context larger than one that is merely "Japanese." Light is essential to human habitations, and by so powerfully transforming light—and space—shoji can also enrich and satisfy the human being. Living with shoji affirms our natural link with the special rhythms of light and shadow.

To work outside of Japan, however, shoji concepts must be translated and adapted into contemporary international vocabularies. Shoji are functional as well as decorative, and not all shoji are created equal. American spaces in particular have their own unique demands, as do modern American lifestyles. One has to think about how the shoji is going to affect light in the room throughout the day, how the panels can be arranged for maximum control of the view, and how having shoji in the home may change—for better or worse—traffic flow and the pace and style of everyday life. A purely Japanese treatment will not always be practical.

The primary focus of this book is on woodworking, specifically shoji making. Shoji making involves the fundamental woodworking techniques of laying out, planing, chiseling mortises, and sawing tenons. Introduced in part 2 are the traditional Japanese handtools that perform these tasks. These simple-looking tools are in fact highly sophisticated in both concept and use. The contemporary mastery in every nation of the tool making and woodworking crafts is the cumulative legacy of generations of skilled craftspeople engaged in intensive labor. Japanese planes, chisels, and saws have evolved over centuries of use.

*even the smallest shoji
is as big as the moon*

One need only look at the Japanese samurai sword, still manufactured by methods engineered almost a thousand years ago, to understand how traditional handwork achieves a level of excellence unsurpassed by modern technology.

The obvious problem with "book learning" about crafts—as opposed to apprenticeship—is the lack of opportunity for the daily repetition of tasks and techniques demanded by the work itself. Repetition is essential for mastery and to extend the range of one's skills. This taming of the dragon inside oneself, and between oneself and one's tools, rewards with the confidence gained from the challenge of concentrated manual labor. How to think about one's work is a beginning: the hands and heart must learn as well.

Part 3 details at length how to measure and build a 24" by 36" screen. Part 4 contains ideas for projects and applications. In the interest of space, there is no repetition of part 3's construction details in part 4, nor are specific dimensions given, since these would ultimately need to be revised to suit individual installations. The techniques of shoji making, you will discover, are fairly straightforward. What needs special attention is design, layout, and control over one's tools. Also important are a clear understanding of the task at hand, observing common-sense safety rules, and joy and satisfaction in the accomplishment of something worthwhile.

For some readers, the interest in this book may be not so much woodworking as general knowledge of shoji making—access to information and ideas and as a basis for evaluation. This can lead to a more informed and sensitive choice of shoji for the home, and to a deeper and more receptive appreciation of shoji art and interior environments.

Many people in Japan and America have contributed to this project—friends, teachers, carpenters, shoji makers, architects, interior designers, proud owners of custom-designed screens, and tool and paper suppliers—too many people to thank individually by name, except for my special thanks to my wife, Karen Ehrhardt. This book could not have been completed without their many efforts, and to all of them I would like to extend my deepest gratitude. I would like to dedicate this book to anyone who has ever marveled at the work of an unknown craftsman, and especially to all who see in shoji not just a paper-backed wooden-frame lattice but the embodiment of an architectural tradition of great beauty and sophistication, one that can enrich our lives as well as our living spaces.

Perhaps the main actor in the theater of performance that is the traditional Japanese house is the shoji screen. This wooden-frame, papered, sliding panel epitomizes grace of movement in all its essentials. The aim of this performance is not just the reduction to the simple or the seen but the dynamic half-revealed, like an intangible shadow caught midway in its flight.

The half-title page shows a lantern of natural stone and shoji, designed by Karen Ehrhardt and the author. The title page shows shoji screens in the n ain room of a house in Tiburon, California, designed and built by Len Brackett of Eastwind, Nevada City.

Cover and book design, artwork, and layout by Donald Dean Illustration/Design. Line drawings based on sketches by the author. Photograph on front cover by Jeffrey Westman. Photograph of lantern on back cover by Karen Ehrhardt and Adam Cavan; lantern designed by the author. Photograph of Sweet Residence on back cover by Jeffrey Westman; shoji and *fusuma* by Allen Trigueiro and Ann Marks-Korematsu.

Photographs by Jeffrey Westman except pp. 1, 7, 75, 88, 93, 96, Karen Ehrhardt and Adam Cavan; pp. 9, 16 (*top*), 45, Shigeo Okamoto; p. 10 (*top*), courtesy Kodansha; p. 10 (*bottom*), Keisuke Kumakiri; p. 11 (*top*), courtesy Sumiya; pp. 11 (*bottom*), 12, Osamu Murai; p. 15, Michael D. Arden; p. 20, Metcalf-Fritz Photograph Collection, University of California, Forestry Library; p. 63, Earle Sidelle, courtesy Design Shoji; p. 64, courtesy Robert Brockob; p. 65 (*top*), Cap Carpenter; p. 65 (*bottom*), courtesy Hiroshi Sakaguchi; p. 66 (*center*), courtesy Design Shoji; p. 66 (*bottom*), courtesy Al Klyce; p. 68 (*top*), Jaime Ardiles-Arce; p. 68 (*bottom*), Kent Marshall; p. 69 (*top*), Paul Warchol; p. 69 (*bottom*), Tom Vinetz; p. 85, courtesy Design Shoji, 841 Kaynyne, Unit B, Redwood City, CA 94063 (415-363-0898).

Quotation on p. 10 from *In Praise of Shadows* by Jun'ichiro Tanizaki, Thomas J. Harper and Edward G. Seidensticker, trans. (New Haven: Leete's Island Books, 1977). Lattice patterns on pp. 70–73 redrawn with permission from *Washitsu Zosaku Shusei* by Saburo Yamagata (Kyoto: Gakugei Shuppansha, 1979). Paper-folding pattern on p. 62 based on "Cosmos Blossom" in *Mon-Kiri Playtime* by Isao Honda (Tokyo: Japan Publications, 1967).

Composition by Harrington-Young, Albany, California.

Distributed in the United States by Kodansha America, Inc., 575 Lexington Avenue, New York, N.Y. 10011, and in the United Kingdom and continental Europe by Kodansha Europe Ltd., Tavern Quay, Rope Street, London SE16 7TX. Published by Kodansha International Ltd., 17-14 Otowa 1-chome, Bunkyo-ku, Tokyo 112-8652, and Kodansha America, Inc.

Copyright © 1988 by Kodansha International Ltd.

Printed in Japan

First edition, 1988
03 04 05 17 16 15

LCC 87-82860
ISBN 0-87011-864-1
 4-7700-1364-7 (Japan)

www.thejapanpage.com

Open panels in shoji screens segment the view of the garden into four different landscapes. Sekisontei, Kyoto.

DESIGNING WITH SPACE AND LIGHT

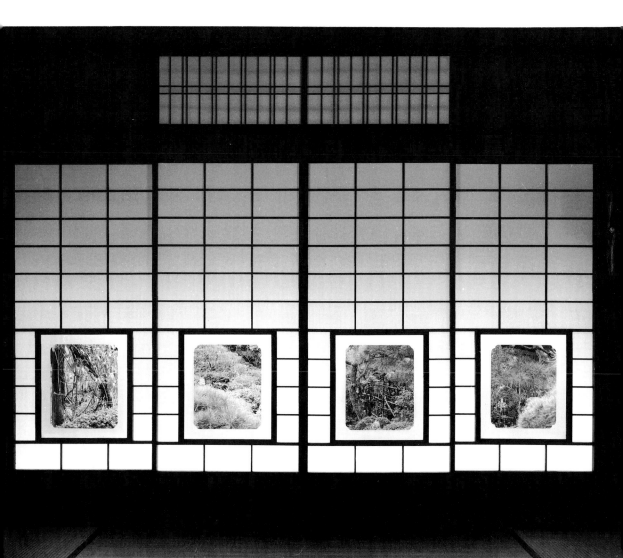

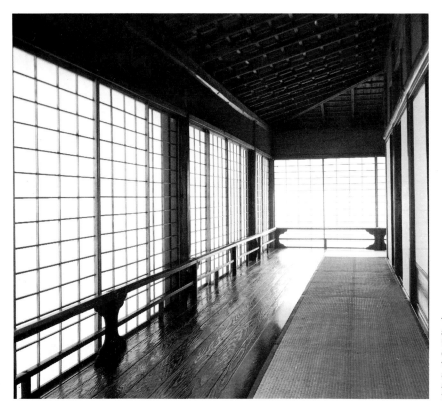

The veranda of the First Room at the New Palace of Katsura Rikyu in Kyoto. Shoji form the outer skin of the structure, while the living quarters are inside another layer, behind the *fusuma* screens, the tatami, and the corridor.

In his famous essay "In Praise of Shadows," the novelist Junichiro Tanizaki likens a traditional Japanese room to a black and white brush painting, with "the paper-paneled shoji being the expanse where the ink is thinnest, and the alcove where it is darkest." Areas of light and shadow play off against each other in strange ways, particularly in the deepest recesses of an alcove. Here the muted intensity of light from the shoji hardly changes with the hour or the season. "Have not you yourselves sensed a difference in the light that suffuses such a room, a rare tranquility not found in ordinary light?" Tanizaki asks.

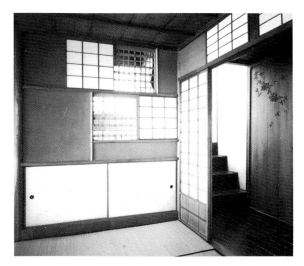

Rooms on the third floor of Tomatsuke, a merchant's home built in Nagoya at the turn of this century and now located in Meiji-mura Museum. Shoji are used in the pass-through, the transom, and the wall between the lower room and the raised room behind it. The space below the back room is used for storage.

The Sumiya in Kyoto, designated a National Cultural Treasure, represents the flowering of merchant tastes in the Edo period (1615–1868). The building served both as a house of dining and refined entertainment and as a salon for political leaders and cultural luminaries. The intricate shoji screens in the room here add strong decorative motifs to the otherwise plain yet expansive interior.

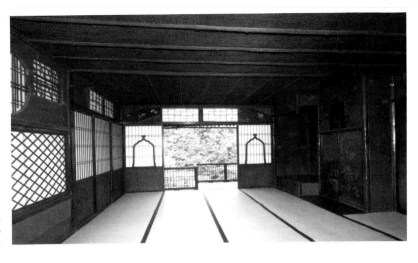

Shoji built into the ceiling introduce light from this home's southern exposure. *Fusuma* screens (*right*) can be slid across the broad veranda to separate the raised Japanese-style tatami room from the Western-style living room. Note the large scale of the shoji panels and the lattice pattern. Tanabe Residence, Tokyo.

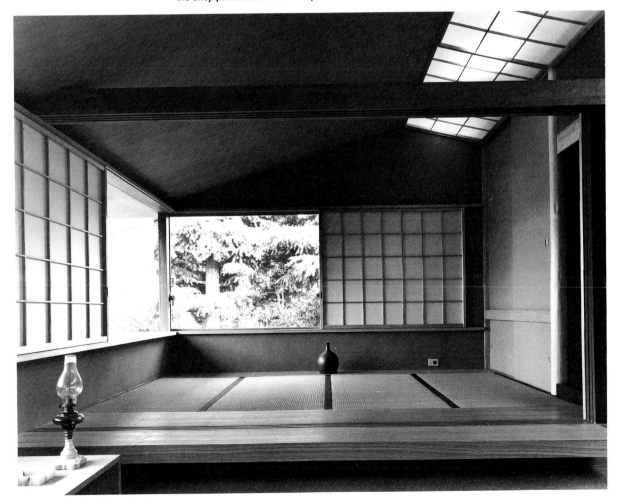

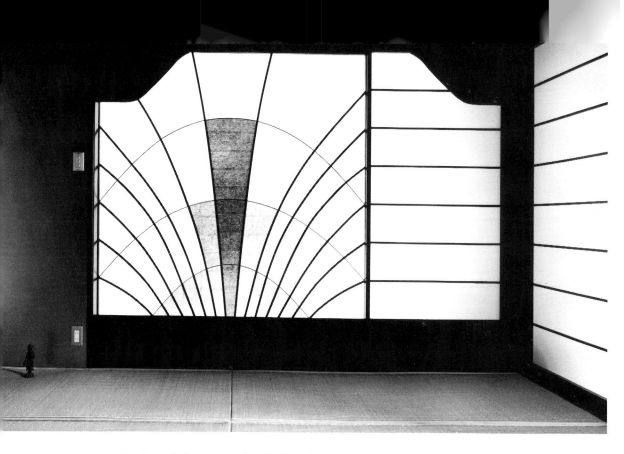

Two homes in Japan by architect Kan Izue. The window design in the Kimura House in Hyogo Prefecture (*above*) dates back to the 1300s and was used in Zen temples. There is a mathematical purity to the arcs of the shoji; according to the architect, special papers displaying the traditional Japanese colors of rust, reddish purple, and moss green are used in the center panels to challenge the stoical priest by suggesting the faint smile of a woman. The Nakamura House in Osaka (*below*) uses entryways in the shape of hands folded in prayer and an eccentric dropped curve above the traditional tokonoma alcove to encourage a mood of *yugen*, an ideal of distant, mysterious beauty.

All human civilization and agriculture depend on light, which in Japan is associated with the sun goddess, supreme in the Shinto pantheon. White, the color of handmade shoji paper, stands for purity. In a Japanese room fitted with shoji screens that scatter and diffuse the light, the pupil of the eye doesn't have to work so hard adjusting to extremes of bright and dark. The result, perhaps, is a true physiological tranquility associated, in the Japanese mind at least, with both the elemental and the spiritual.

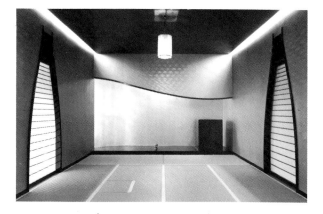

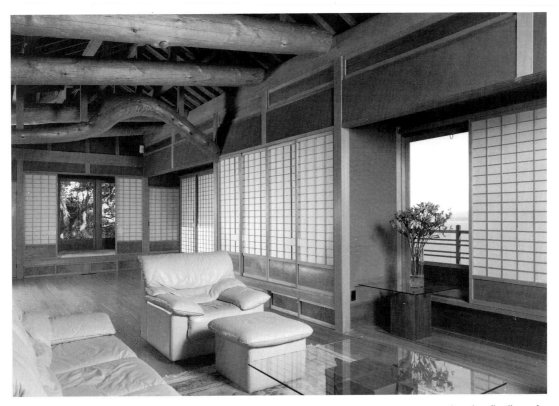

Massive logs offer a powerful contrast to the crisp, fine lines of shoji screens in this American adaptation of a Japanese country home. The shoji are fitted with hipboards for stability and protection. In back, the screens open to reveal an alcove with a broad, cushioned bench for relaxing. Designed and built in Tiburon, California, by Len Brackett of Eastwind.

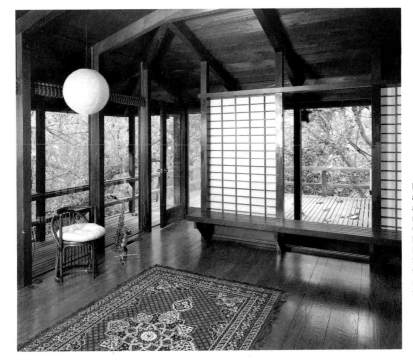

Redwood shoji, a broad veranda, and post and beam construction are just a few of the Japanese elements adapted by architect Charles Callister in the mid-1950s for this home on a wooded hillside in Oakland, California. The climate in the San Francisco Bay area—the winters are extremely mild—is well suited to Japanese-style buildings that interface closely with nature.

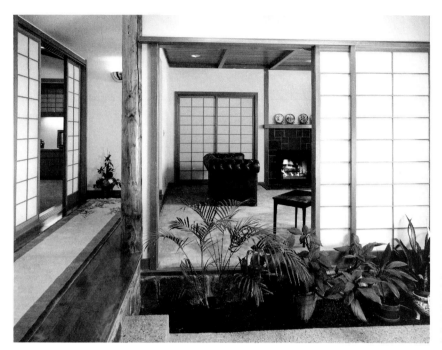

Sandwich shoji (with the lattice visible from both sides) are used between conventional Western rooms to manage space in this home. The raised wooden corridor and the pavement at the entryway suggest a Japanese inn. U.S.A.

Outside Japan, shoji have found new uses and new locations in the home. While shoji may give a Japanese "look" to a Western interior, a shoji installation that merely mimics the Japanese style is bound to look out of place. Shoji have function as well as form, and they must relate to the overall design of the home (inside and out), to its traffic patterns, and to the lifestyles of its inhabitants.

White pine shoji designed by architect Vernon DeMars fill one wall of a room overlooking a creek. At left the screens disguise a closet. The lattice pattern is repeated at right above a cushioned bench. Behind the bench is a narrow well into which the screens can be dropped to reveal the entire view.

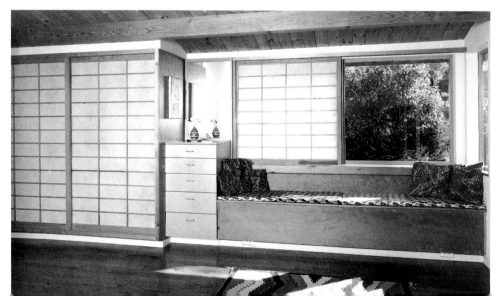

In traditional Japanese homes and tearooms, the tokonoma is a raised alcove located at one end of a room and used to display seasonal scrolls and flower arrangements. Here, architect David Takamoto gives a bedroom a traditional look with a simplified tokonoma and shoji. In the adjoining bathroom, a platformed area with tub and pillar echoes the same idea, but in a most untraditional way. Shoji in any bathroom area must use plastic or fiberglass sheeting.

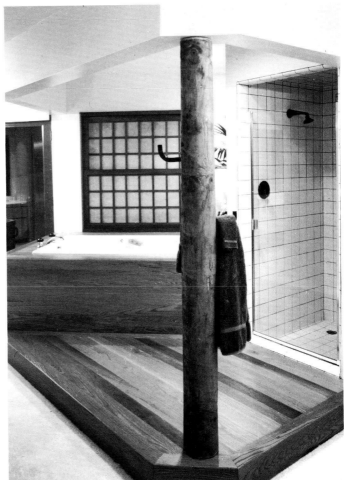

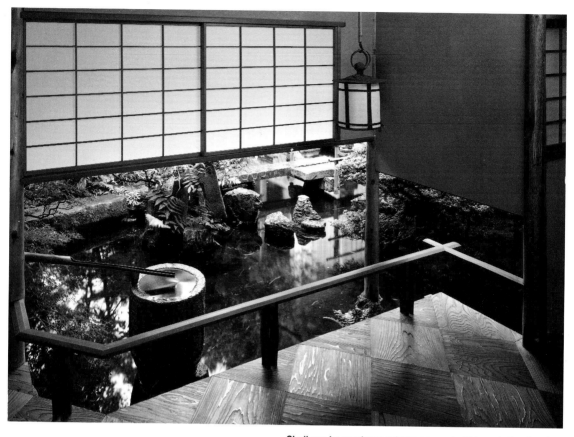

Shoji can be used as a privacy screen to hide part of a view that is only fully revealed elsewhere, in this case farther down the corridor to the right. Note the balanced profusion of naturalistic and geometric textures, from the regular pattern of the shoji lattice and railing to the bold grain on the veranda's cedar planking, to the abundant greenery and rockwork of the water garden. Shikunshien, Kyoto.

Part of the traditional Japanese love of nature is reflected in the Japanese home, whose wide verandas and broad, overhanging eaves reach out to the world and make the natural landscape almost a part of the interior furnishings. Shoji moderate this dynamic interplay between inside and outside, softening the light and overlaying the view with a human and geometric latticework. They train our senses to a new appreciation of space, and encourage us to participate in our living environments.

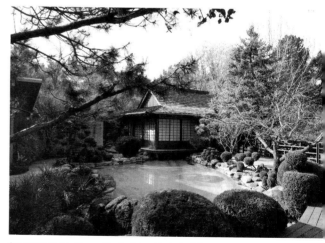

An outdoor pavilion with double-sided shoji juts out over a pool naturalistically trimmed to look like a pond. On the other "shore" is a typical California ranch house. From a distance, the shoji patterns are highly visible and inviting, especially at night, with the pavilion lights on.

This shoji panel on an outdoor gate uses frosted glass. The stepping-stone approach from the garage, the rockwork, and the unfinished wood framing casually combine a number of traditional Japanese garden elements in an American setting.

WOOD, PAPER, AND TOOLS

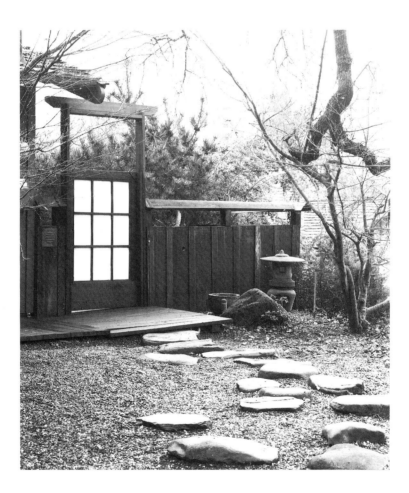

Traditional Aesthetics, Modern Applications

The traditional home in Japan was designed with summer in mind. No one is sure exactly when shoji screens were introduced into it. They are thought to have evolved from freestanding and folding screens of a type used in China. At first these early "shoji" were used as interior partitions in the mansions of the Japanese nobility, but their usefulness along the outer walls of the structure gradually became clear: fitted with translucent paper, they could screen out the hot sun without making the home overly dark, or they could be opened to admit the breeze directly. By the 14th century in Japan, shoji as we know them today were in use even in the homes of commoners. They are now a symbol, both of classical Japanese beauty and of an approach to living that maximizes spatial flexibility within the home.

In typical Western stick framing, the walls are load bearing, carrying the weight of the building and providing structural stability. Western walls are necessarily fixed. They enclose the structure and provide only a limited number of access points.

In contrast, the traditional Japanese house is based on a modular system of wooden members connected with joinery. The weight of the roof and building is transferred through the larger beams and supported by the posts. Unlike the Western home, the resulting timber-framed shell is characteristically free of fixed walls. Where needed for privacy, shelter, or security, solid exterior walls are made by weaving split bamboo between the posts and packing it with mud and straw or clay. The interior rooms are drawn; space and privacy are regulated within the household by freestanding screens or by *fusuma*, opaque panels that slide in tracks between the rooms. The layered paper or cloth surfaces of *fusuma* are often decorated with patterns or paintings.

These open-framed buildings with their large roofs and broad overhanging eaves work wonderfully well in the hot and humid Japanese summers (although they are rarely built anymore, being considered uncomfortable and primitive, especially in the cold winters). Solid wooden panels called *amado* are installed along the outside perimeter for security and protection from heavy storms, but these are usually removed

SHOJI CONSTRUCTION

Despite their complex function within the home, shoji are of eminently simple construction. A lightweight wooden frame consisting of horizontal "rails" and vertical "stiles" supports a lattice of thin sticks, called *kumiko* in Japanese. Paper or other translucent sheeting material is attached to the back (outside) of the lattice. A shoji may be a single layer of kumiko with the paper glued onto the back, or a sandwich type with two layers of kumiko and the paper in between. This double lattice shows the grid from both sides, and is popular in the West, where it seems more "finished." In Japan, most shoji are single sided, one explanation for this being that a shoji is like a human head: it has only one face and one backside.

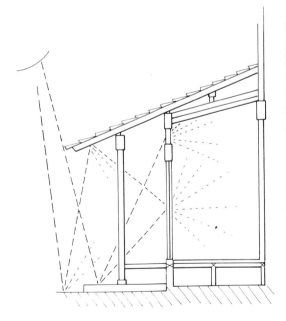

The summer sunlight entering a Japanese home is indirect, screened out by the large overhanging eave and then filtered by the shoji.

during the day for light and ventilation. The shoji, which are set in tracks between the interior and the veranda, are in effect the eyes and the skin of the dwelling. Located well under the eaves, they capture the indirect light that resides there and diffuse it into the home. This paper glow allows the outside to become a part of the spatial organization of the interior, animating it without destroying its integrity.

The decision to install shoji is in part a decision to participate in the rhythms of nature. It is therefore useful to think of shoji not as barriers but as filters. They give visual privacy and a degree of wind-draft reduction, but they offer little in the way of heat insulation, soundproofing, or security, unless appropriate materials, such as safety glass, are built into their design.

Shoji are usually designed to slide in tracks at top and bottom, but with slight structural modification they can also be hinged or hung. Adjusting the size and position of the opening brings cooling breezes into the room at the same time it takes maximum advantage of the view. The ability to highlight a favorite tree or skyline while blocking off an unsightly wall or backyard is especially welcome in crowded urban areas.

Nontraditional uses for shoji and shojilike materials are constantly being developed in Japan and the West. Choices abound in the variations of wood, finishes, lattice designs, paper and paper substitutes, and tracking hardware. Skylight screens, decorative wall light boxes, outdoor privacy fences, and office partitions are just a few of the new applications being brought to the home and the workplace. These designs must be carefully thought out, however, since there is little precedent for them. Shoji make a strong graphic impression and can easily become the focus of interest in an enclosed space. In an otherwise bare high-tech room this may not be a problem, just as in a sparsely furnished Japanese-style room the regular geometries of the kumiko patterns echo the straight lines of the tatami, posts, and beams. In a conventional Western-style home, however, these same geometries can overpower the softer lines of sofas, lamps, and tables.

In Japanese fashion, therefore, a philosophy of restraint should guide the design. The beauty of a shoji screen is most evident in its details, particularly in its elegant simplicity and precise workmanship. Whether plain or complex, a shoji should reveal an ease of placement in all its parts.

PURCHASING SCREENS

In any project, the budget should be understood from the very beginning. Discuss your needs frankly with those you hire. Remember that high-quality, custom handwork and "made to fit" orders are more involved and hence not inexpensive. Also, realize that it takes more materials and skilled labor to lay out and construct a double-sided shoji than a single-sided one. Prices quoted "per square foot" are sometimes only a base price to which the costs of tracking, hardware, painting, and installation are added.

Today both handmade and machine-made shoji screens of good quality are available in the United States. Generally the machine-made screens are the less expensive.

With handmade shoji, each piece is carefully laid out, as with the demonstration shoji in part 3. Here, a hammer and a chisel are used to create the mortise, and a handsaw is used to cut the tenon. Before assembly, the wood is finished by hand with a special burnishing plane. American woodworkers who use Japanese tools for these tasks are quick to point out how the depth and luster of the freshly planed wood become an intrinsic part of the design.

With machine-made shoji, a mortise machine or mortising bit is used to drill the mortise hole, and various tenoning attachments and devices are used to cut the tenons and shoulders. Repetitious layout is eliminated once the stock is cut and the machines are set up. The finished pieces are usually sanded and stained or painted.

Factory-made shoji are available in standard sizes at many discount retailers, futon shops, and department stores. The advantage of their cheap price is usually negated by their lack of size and variety and by their general disregard for quality control and attention to detail.

Shoji makers are sometimes listed under "Screens" in the yellow pages. You can also contact woodworking stores and associations, interior designers, cabinet shops, and Japanese crafts and cultural organizations for other leads. The owners of custom-made shoji should be only too happy to put you in touch with "their" shoji maker. And good shoji makers should be willing to give you references and at least show you photographs of their work.

The Port Orford cedar grows in small patches in northern California and southern Oregon. Virtually all its timber today is sent to Japan, where it is used for temple and shrine building. This wonderful, aromatic species is in serious danger of becoming extinct, due to a root fungus that can be transported from site to site by contaminated trucks. Once it is gone, Japanese-style carpenters will be hard pressed to find another joinery wood of such fine quality.

About Wood

Designing a shoji involves many steps and decisions, and one of the very first choices to make is what kind of wood to use for the frame and for the kumiko. Usually these are woods of the same species, but they need not be, especially if the screen is to be stained or painted. Kumiko of bamboo or woven reeds are sometimes used. Since most varieties of wood can be used for shoji screens, personal preference can largely govern your selection. In order to insure a reasonable life of service and pleasure from the installation, however, give special consideration to how the screens will be used, who will use them, and where they will be located (what kind of surrounding decor, how much exposure to the sun, and so on).

Traditionally, cedar and cypress woods have been used in Japan for shoji and for the architectural elements that house them. These softwoods lend themselves especially well to the needs of the shoji screen. They are lightweight and straight grained. They are good for joinery, because their cellular structures are consistent in density, not layered with hard and soft growth rings like redwood, Douglas fir, and hemlock. Resilient and flexible, these woods are less likely to snap when used for long, thin kumiko. Being resistant to decay and pest damage, they are a good choice when adding interior and exterior installations.

The rails and stiles of a traditional shoji screen are built using a simple mortise and tenon joinery construction. Gluing is unnecessary, since the softwood cedars and cypresses compress across the grain to hold the tenon in place. Many Americans, however, may prefer hardwood—oak or mahogany, for example—for their shoji to complement their existing cabinetry and furniture. Unfortunately, these hardwood varieties don't lend themselves to pressure fits as well. When using woods like oak or mahogany for shoji, therefore, you may have to glue the joints together. Chamfer the corners of tenons about 1/16" so air and excess glue can escape from inside the joint.

For those so inclined, screw and metal fastener systems offer a purely mechanical, nonjoinery alternative. Should a frail kumiko snap and have to be replaced, however, a glued and screwed shoji can be difficult to break apart and reconstruct without doing even more damage.

Frame and kumiko members were traditionally

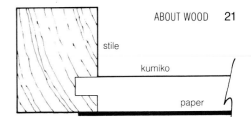

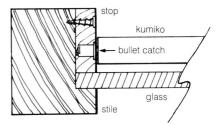

Cross-section of a standard shoji with lightweight framing to support kumiko and paper.

sized in Japan to be very lightweight, because they only needed to support the thin paper that was glued onto them. With modern applications, however, come new structural and design problems. Paper is often replaced by stiffer and heavier plastics and glass. Building codes governing entryways and other openings make most American screens taller and wider than Japanese ones. The American lifestyle, moreover, usually isn't geared to a shoji's delicate paper and wood latticework. All these factors mean that your basic shoji design may need to be modified to bear a heavier load.

You can thicken the frame and the kumiko to strengthen them, but this might end up defeating the lightness of the shoji design that is one of its most attractive characteristics. Another option is to use "hipboards," solid rectangular panels fitted onto the lower quarter or third of a shoji. Hipboards offer stability against shear in a tall screen, and protect the slender lower kumiko from a wayward boot or vacuum cleaner. They are also an opportunity to display the beauty of natural wood. Consider a decorative, finely figured hardwood like walnut or cherry here.

When purchasing wood, remember that frame members must be straight, not bowed, twisted, crooked, or prone to splitting. This insures proper alignment and ease of movement through the upper and lower tracks. Only select seasoned lumber. Seasoning (air drying is better than kiln drying, which can make the wood too brittle) removes moisture from green wood, stabilizing it by relaxing stresses in the wood grain fibers. Only use wood that has been seasoned in your locality, since wood that has adjusted to a different level of humidity may start changing again after you start working it. To be safe, resaw your stock to a secondary oversize and let it recure before milling to a final dimension.

Modern shoji that support heavier glass must be made proportionately larger.

Shoji with wooden hipboard (koshi).

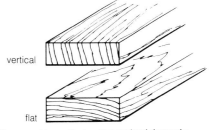

Whether wood is vertical or flat grained depends on how it was cut from the log.

Stack wood you buy to season it.

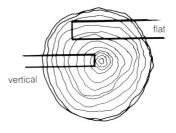

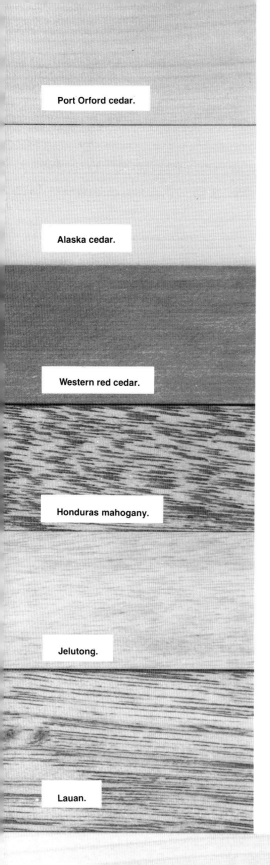

Port Orford cedar.

Alaska cedar.

Western red cedar.

Honduras mahogany.

Jelutong.

Lauan.

Poplar.

Black cherry.

Wood Varieties

On these pages are examples of common woods that are suitable for shoji frames and kumiko. When selecting lumber, look for (1) clear, straight grain, (2) even and tightly closed pores, (3) light weight and flexibility, (4) stability in all dimensions, (5) thorough seasoning, (6) ease of working, and (7) ability to take a good finish. Small, tight pin knots can be structurally and aesthetically acceptable, but larger knots weaken the wood, are hard to work, and distort as the wood absorbs moisture from the environment. When choosing wood for kumiko, select the straightest grains available.

Port Orford cedar (*Chamaecyparis lawsoniana*, Lawson cypress, Oregon cedar, white cedar): very fragrant; usually straight grained and clear; perfect density for joinery; good flexibility; yellow to pale brown color; works to beautiful finish with Japanese plane; high in natural oils; one of the best woods for exterior use; usually doesn't raise grain or splinter in seats and decks; the preferred wood among traditional shoji makers. Alaska cedar (*Chamaecyparis nootkatensis*, yellow cedar) is more buttery yellow and richer grained than Port Orford; weathers to silver gray; works exceptionally well and is good for joinery. Western red cedar (*Thuja plicata*) is less fragrant and more spongy and crushable; ranges in color from deep red brown to umber brown; was used by Indians in the Pacific Northwest for canoes and buildings.

Mahogany (*Swietenia macrophylla*): good for staining or painting; porous; strong; even structural density; tends to dark reds and browns in color; attractive grain. Jelutong (*Dyera costulata*): very similar to mahogany, but less expensive when available; much lighter in color. Lauan (*Shorea* spp.): often used as a mahogany replacement; stringier fiber; not as dense; takes paint well.

Poplar (*Liriodendron tulipifera*): little grain figuring; green yellows to brown with dark streaks; good for painting and staining; little porosity in surface or endgrain; stable; works well.

Black cherry (*Prunus serotina*): distinct and fine straight grain pattern; light to rich reddish brown in color; strong and stable; good for joinery; lightweight; stains evenly; works well.

Red alder (*Alnus rubra*): beautiful pinkish browns and nice figuring; somewhat brittle; not too porous; works and planes well; inexpensive; takes oil and stains well; somewhat dry owing to lack of natural oils.

Sugar pine (*Pinus lambertiana*): white to light brown in color; blotches when stained; fiber is even in density but high compression and porosity make wood crushable and fragile; lightweight; easily worked and finished.

Redwood (*Sequoia sempervirens*): density of growth rings uneven; tends to be too spongy for pure joinery; good water and rot resistance; "old growth" or wood with tight growth rings is best.

Douglas fir (*Pseudotsuga menziesii*, red fir, Douglas spruce, yellow fir): tan to red in color; can be painted and stained; highly contrasting growth rings; may be brittle and unstable in kumiko sizes; prone to splintering and cracking; generally available.

Walnut (various species): hard and dense; works cleanly but may be too porous; somewhat brittle when used for kumiko; can have highly figured grain; light to dark brown in color; oils well; too beautiful to paint!

Teak (*Tectona grandis*): dense, waterproof, and strong; looks as good as its price; very abrasive to tool edges; usually dark colored, with strong grain pattern and much figuring; full of natural oils and waxes.

Oak (various species of red and white): widely used by American woodworkers; very hard; porous end-grain; sands and stains well; tends to be brittle and lack consistent density; not particularly moisture or insect resistant; coordinates nicely with many American interiors but requires special care and caution when doing very small shoji joinery.

Red alder.

Sugar pine.

Redwood.

Douglas fir.

Red fir.

Eastern walnut.

Eastern oak.

Teak.

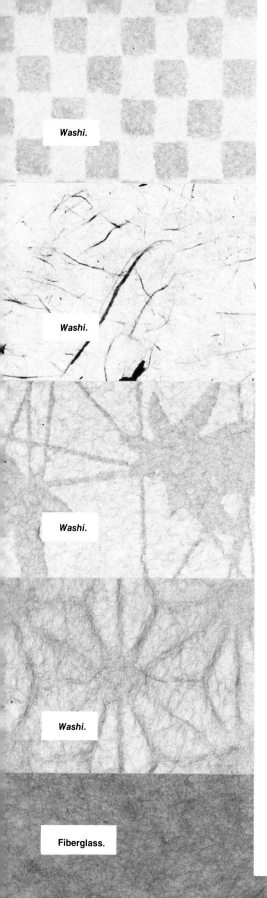

Washi.

Washi.

Washi.

Washi.

Fiberglass.

Paper and Paper Substitutes

Another important choice involves the material for the "face," the area spanned by the kumiko between the rails and stiles. In Japan, "rice" paper has traditionally been used here (a misnomer; traditional shoji paper in Japan was made not from rice but from the inner bark of *kozo*, the paper mulberry tree). "Rice" paper is commonly sold in the United States in art supply stores and comes in rectangular sheets or rolls. Roll paper generally contains pulp, rayon, and other synthetic fibers that increase strength and keep costs down.

Japanese paper, called *washi*, has traditionally been used on shoji for several reasons. It is lightweight and translucent (about 50 percent of the light passes through). While soft, it is surprisingly strong and will last a long time on a shoji screen provided it is not exposed to moisture, roughness, or sharp objects.

Washi's strength comes from several factors: the length of the fibers, the use of a viscous secretion from *tororo-aoi* (hibiscus family) to keep the fibers suspended in the mold longer, and the continuous motion of the mold during sheet forming. The net result is a sturdy sheet of intricately interwoven long fibers. Over time, most modern-day shoji papers will yellow. In Japan, it is the custom to repaper shoji with fresh white sheets of *washi* at year-end to purify the home before New Year's begins.

Traditional shoji lattice spacings were based on the sizes of the papers available to the shoji maker, since the paper was applied so that its edges overlapped behind horizontal kumiko. Paper sizes varied from region to region in Japan. The most widely admired shoji paper in Japan was from Mino province and came in sheets 10¾" wide.

Today Japanese papers are manufactured in rolls and in so many different sizes that for just about any lattice design there will be a suitable paper available. Some Japanese rolls and sheets are available in a standard modular width of about 36", allowing them to be installed without regard to the kumiko spacing. Shoji purists view this situation with alarm, although there is still a tendency even among modern designers to maintain traditional spacings, perhaps because these, being the most familiar, are the most pleasing to the Japanese eye.

Obviously in America you need not be limited by the traditional designs of old Japan. Feel free to experiment with non-Japanese quality papers, fabrics, or other materials. In the end, however, you may decide that although Japanese paper is expensive and needs replacement often, it can be wonderfully translucent and sensually rich—exactly what you want in a shoji. Especially consider paper for fixed installations in low-traffic areas, and in households not also inhabited by young children and cats. Never use paper where it will come into contact with window glass and condensation.

Among the nonpaper materials you can use are various plastic sheetings and even frosted glass. These are durable and easily washed. Widely used by many American shoji makers is a plain white fiberglass sheet made by the Great Lakes Paper Co. and sold under the name Synskin. Synskin comes in rolls 48" wide. It cuts readily and will not degrade, although there have been reports of occasional brown spotting from moisture. Choose fiberglass for its durability and insulating properties.

By far the greatest variety of artificial papers is found in Japan. The Warlon company in Nagoya sells rolls of paper reinforced with rayon as well as an assortment of PVC and acrylic sheets—some of which include laminated *washi*—of various thicknesses and designs. Many of these are manufactured not for shoji but for lighting fixtures, but there is no reason why they can't be adapted to American designs.

Tyvek ("spunbonded olefin") is a newer, perhaps less versatile candidate. Made by Dupont, it is commonly used for house wrap and for security envelopes. Tyvek is less translucent than fiberglass, but it is extremely strong, and the swirls of polyethylene fibers are interesting against the light. Tyvek should not be used outdoors, since it will break down in direct sunlight unless specially coated. Try it for shoji on closets and cabinet doors, or in bathing areas where lightness and moisture resistance are especially important.

While purists (both in Japan and America) may not care for these new products, most craftspeople are pragmatic enough to recognize that without such durable materials, shoji might never find a place in a fast-paced modern home.

PVC + *washi* + PVC

PVC + *washi* + PVC

PVC + *washi* + PVC

PVC + *washi* + PVC

Tyvek.

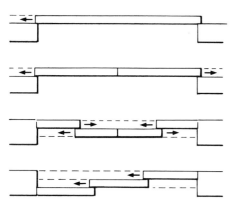

Panel configurations. When the screens are "open," they are usually stacked in their tracks. Tracks can also be extended onto the surrounding walls to afford a better view or passage.

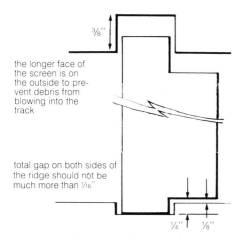

3/8"

the longer face of the screen is on the outside to prevent debris from blowing into the track

total gap on both sides of the ridge should not be much more than 1/16"

1/4" 1/8"

A ridge is rabeted on top and bottom of each screen. The ridge is taller and the track deeper at the top.

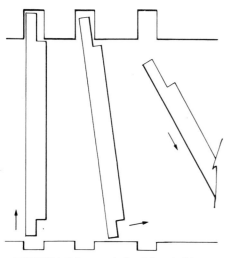

Installation and removal of a sliding shoji is easy. The lightweight screen is simply lifted into the upper track until the lower tenon and dado disengage.

Installations

In American homes, multiscreen shoji installations are usually located in areas otherwise occupied by curtains, drapes, and blinds (that is, in front of windows and patio doors), in pass-throughs connecting rooms within the home, or in front of closets and other storage areas. A screen less than 24" wide looks cramped and is too narrow to be practical as a doorway; in a multiscreen installation it would require you to move more than one screen each time you wanted to pass through. Beyond 40", a screen can become too heavy to support its own weight without some kind of structural reinforcement like enlarged rails at top and bottom. Three parallel tracks for sliding the shoji is plenty for most installations, although you can use more if the opening is deep enough. You need 1/8" to 1/4" clearance between screens in their tracks.

TYPES OF SHOJI INSTALLATIONS

There are many different ways to install shoji in your home. When designing your shoji, think carefully about traffic patterns and who will be opening and closing the screens. Remember that being able to move the shoji gives you control over light and view. Design your screens to maximize both.

1. *Sliding*. This is the traditional Japanese method. The rails of the shoji are rabeted to form ridges that fit into tracks (dados) at top and bottom. Rabeting enables the screens to have a minimum of passing clearance without reducing the amount of wood between the dados. The lower track groove is shallower (1/8" is enough) than the top and supports the entire weight of the screen as it moves. The upper track groove, at least twice the depth of the lower to allow easy removal, serves only to keep the screen vertical. Because the entire screen is supported from below, and not from the side as with a Western-style hinged door, the frame needs only a minimum of structural reinforcement.

A modern alternative to this sliding mode calls for a wheel in a housing to be mortised into the bottom rail of the shoji. The groove in the wheel runs on a metal track that is mounted on the floor or threshold. An omnidirectional caster can also be used in an inlaid hardwood track. The rolling action of the wheel or caster

eliminates the friction of wood-to-wood contact in the bottom track. Such an installation is suited to very large panels and to panels that contain glass, thick plastic sheeting, or other heavy materials. It also works well in high-traffic areas where the screens have to operate quickly. The top is a simple tenon/ rabet and dado.

2. *Hanging*. With most sliding screens, the tops of the bottom tracks are made level with the flooring so that people don't trip as they pass through the opening. If the screens are added later or are installed in a carpeted area, it may not be possible to inlay the tracks. Instead, the screens can be fitted with a roller device at the top and suspended from an upper track.

Most hardware stores stock a variety of tracking devices and guides that help prevent the screens from swinging as they move. Many systems use adjusting screws to make the screens plumb. Unfortunately, these devices are often unattractive. Hide them from sight by a valance or other device (see part 4). Rollers and other mechanical devices can also be quite noisy, and this might destroy the tranquil mood you have labored to create with the shoji in the first place.

3. *Bifold (hinged)*. Although hinges are rarely used with shoji in Japan, they make sense in many American homes. Used with a swivel roller at the top of the screen, hinges allow several screens to operate in a single track, making installation possible in long but shallow openings. Because the screens are stored perpendicular to the track, edge-on to the viewer, the opening is obscured much less than with conventional sliding panels. Unlike sliding screens, hinged screens have a tendency to sag and may need to be stabilized along the diagonal with hipboards or thickened rails.

4. *Freestanding*. Single screens are often used as partial, stationary partitions without tracking systems. They can rest in a stand that can be moved about the room, or they can be attached to a wall, floor, or ceiling. Two or more screens can also be attached at their sides and arranged in a zigzag to make them stand on their own. Since the weight of each screen rests on the bottom, lateral shear here is not a structural concern as it is with hinged screens. Freestanding screens have a decorative, sculptural value and make versatile room dividers that give privacy without cutting off light or closing you in. See part 4 for examples.

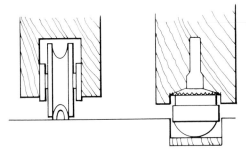

Wheel on metal track and omnidirectional caster in hardwood track.

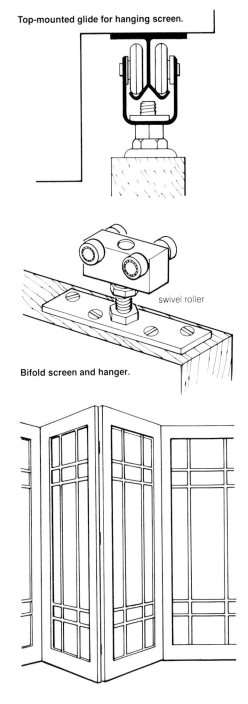

Top-mounted glide for hanging screen.

swivel roller

Bifold screen and hanger.

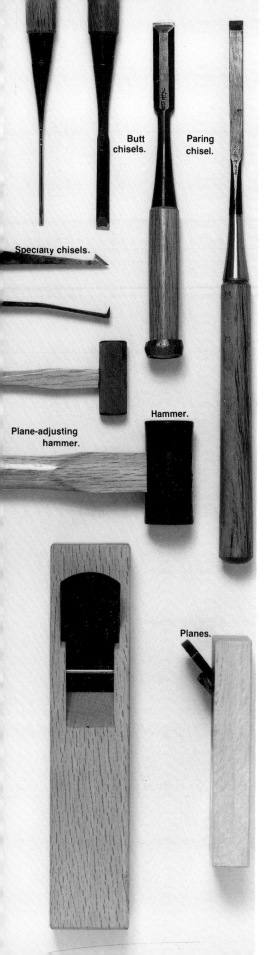

Butt chisels.

Paring chisel.

Specialty chisels.

Plane-adjusting hammer.

Hammer.

Planes.

About Japanese Tools

Although there are a few specialized tools for making shoji, all that is really necessary are the basic wood-working tools: layout implements, hammers, chisels, planes, and saws. Shoji makers in Japan and America customarily use Japanese tools, but there is no reason that shoji screens cannot be made with Western handtools or machine tools of the sort found in the average American shop or basement. Machine tools, in fact, are quite useful when it comes to making uniform pieces in quantity for large-scale shoji installations.

The satisfaction of shoji making, however, comes from more than just cutting the pieces and putting the screens together. The process of woodworking has value in its own right. It is also a means by which you can control and attune yourself to the qualities of the wood and the joinery details that are such an important part of the shoji's beauty. Besides, many machine tools cannot do small-scale joinery any better or quicker than a practiced carpenter working with sharp-bladed chisels and saws.

Over the centuries the Japanese have made hand-tool manufacture into an art. Among traditional craftsmen, and recent Western newcomers to Japanese-style woodworking, high-quality cutting surfaces are held in the greatest esteem. Even more highly esteemed are the natural polishing stones—*toishi*—on which the sharpness of these cutting surfaces depend.

Today, along with the traditional handtools still made in the Japanese village smithy, are many products using modern methods and materials. Some are durable additions, like cutting edges of high-speed tool steel instead of traditional high-carbon steel. Disposable alternatives are also available at reduced cost, like replaceable-blade handsaws with electro-hardened teeth. The benchmark standard, however, remains that which has resulted from centuries of use and perfection.

Most American tools don't approach this standard. In the end, the best reason for using Japanese tools is that they are the best tools available and will permit you to do your best work.

A SHOJI MAKER'S TOOLBOX

At right are the basic handtools and stones traditionally used by Japanese carpenters to make shoji screens. It should be emphasized again that if you already have good Western tools—saws, planes, chisels—you do not have to "retool" Japanese style to make shoji. But for only $20 to $30 you can buy a #1500-grit artificial water stone, a replaceable-blade *ryoba* saw, or a chisel and see for yourself where the benefits lie. Japanese water stones, for example, will work on all your steel tools to make them more effective, increasing your accuracy and speed. Because Japanese saws cut on the pull stroke, they give you greater control with less effort. And while Japanese planes may require regular tuning, they will reward you with a rich, natural finish that highlights the beauty of the wood. Diligent practice with these tools—and practice is required—may well change your way of looking at the common work of the hands.

Look for medium-priced tools of professional quality. A novice will not need professional-grade tools, but remember that inexpensive tools are unlikely to hold up to continued exacting work. A well-made tool will last for many years if properly maintained.

Japanese handtools as they relate to shoji making are discussed in greater detail on the pages that follow. See also the back of the book for lists of tool vendors and books on Japanese tools and woodworking techniques.

Layout Tools
straight edge for plane body (*shitabajogi*)
Japanese carpenter's square (*sashigane*)
marking gauge (*kebiki*)
ink pot with line (*sumitsubo*)
bamboo pen (*sumisashi*)

Chisels (nomi)
butt chisels (*oirenomi*): 3 mm, 9 mm,
 and 15 mm
9 mm paring chisel (*usunomi*)
specialty chisels for cleaning mortises
 (*morinomi, sokosarae, yarinomi,
 kannanomi*)

Hammers (genno)
75–185 gm plane-adjusting hammer
225–375 gm hammer

Planes (kanna)
scraper plane for conditioning plane
 blocks (*dainaoshi-kanna*)
36–48 mm plane for general
 woodworking (*hirako-ganna*)

Saws (nokogiri)
double-edged rip and crosscut
 ryoba: 180–210 mm
replaceable blade *ryoba*
single-edge crosscut *dozuki*
replaceable blade *dozuki*

Polishing Stones (toishi)
#400 grit rough stone
#1200–#1500 grit medium stone
mountain blue or ocean blue stone
#3000 grit artificial finishing stone
 or natural *awase* stone

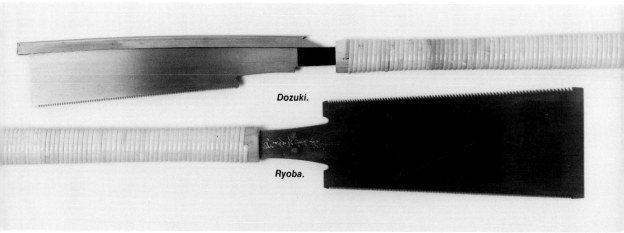

Dozuki.

Ryoba.

Layout Tools

When doing any kind of wood joinery—and shoji making in particular—every piece must be marked or "indexed" so that fits and joints are exact. If the line is not right in the layout, the wood won't be right in the final position. It is especially important when making shoji to lay out the pieces in advance of cutting, and to mark each one as to front, back, top, bottom, right, and left.

Marking tools. Whether you use Japanese or Western tools, layout instruments must produce lines that are clean, accurate, and readable. Any lines you draw must be sharp and consistent in width around the circumference of the pieces. Pencils and felt pens that produce crisp lines are good. Marking gauges can be used in certain locations (on the edges of tenon rip cuts, for example) to score the wood. But they should not be used where the marks will be visible on the final piece.

For drawing straight layout lines, Japanese carpenters use a bamboo marker called a *sumisashi*. At one end it is split along the grain and tapered to enable it to draw fine lines with very light pressure against a ruler or square. The other end is hammered soft and used like a brush to write indexing marks or other rough notations on wood pieces to be assembled. The *sumisashi* needs regular sharpening (but not as often as a lead pencil).

The *sumisashi* is charged with ink from the *sumitsubo*, an ink pot used like the Western chalk line to mark milling cuts or layout lines. The *sumitsubo* consists of an ink well, a storage wheel, and a string of raw silk or cotton attached to a locating pin. The string is pulled through the ink well, pinned to the wood, and then pulled taut and snapped, leaving a very fine line of ink. The ink line does not score the wood and is easily removed when the final piece is finish planed. The ink (*sumi*) is made of charcoal and a binder. Insoluble in water after it dries, *sumi* can be seen on wet wood where a pencil line cannot.

Carpenter's square. A lightweight square is essential for checking angles and surfaces and for aligning saw cuts. The size of the square should be in scale

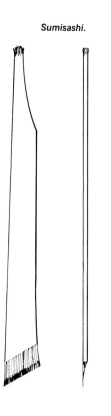

Sumisashi.

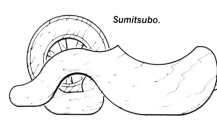

Sumitsubo.

with the work; the large, heavy metal machinist's square and the traditional Western framing square are both out of place when working on shoji. Japanese stainless steel squares are available in traditional Japanese, metric, or English measurements. Their knife edge prevents ink from bleeding beneath the edge of the square when drawing a line with the *sumisashi*.

Marking gauges. Gauges with adjustable single and double blades allow you to score parallel lines of the same dimension on many different pieces, as you would wish to do with tenon rip cuts and the corresponding rip sides of shoji mortises. Gauges come in numerous styles in America and Japan, with the Japanese gauges using blades and not pins or points to score the wood. Pulled toward the user, the sharp Japanese blade easily passes through the grain of the wood without tearing it or being deflected.

Japanese carpenter's square with knife edge.

Chisels

Japanese chisels (*nomi*) work the same way Western chisels do and are used for much the same work—but not for prying, scraping, or cutting nails. There are two basic chisel types: butt chisels can be pounded with a hammer to cut mortises, while paring chisels are worked only with the hands and are used for fine clean-up work.

The Japanese chisel consists of a piece of hard high-carbon steel laminated to a softer, low-carbon-steel backing that acts as a shock absorber. The high-carbon steel forms the cutting edge and can be made extremely sharp. Quick, clean, and precise cuts can be made with a chisel using only light blows from a hammer, and the endgrain inside a mortise can be cut without tearing or pulling out wood fibers in chunks. Because the high-carbon blade is brittle, chipping can still be a problem with these tools, so you may wish to reserve your Japanese chisels for only your finest woodworking tasks.

Located about ⅛" from the end of the wooden handle of a butt chisel is a metal ring that prevents the wood from splitting from a hammer blow. The end of a new chisel should be hit with a hammer repeatedly

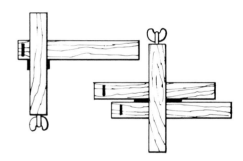

Japanese single- and double-blade marking gauges.

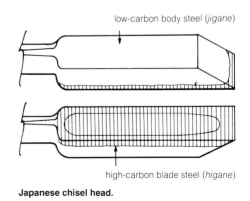

low-carbon body steel (*jigane*)

high-carbon blade steel (*higane*)

Japanese chisel head.

Hammer the top of a new chisel handle until it mushrooms around the metal ring (ferrule) that prevents the wood from splitting.

Yarinomi (top) and sokosarae, two of the specialty chisels useful for cleaning out small mortises in shoji screens.

Japanese hammer, with one flat and one convex face.

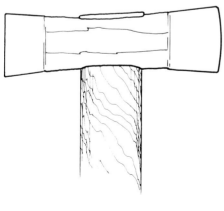

until the wood there flattens and mushrooms over the ring to hold it in place. Should the ring loosen in time, remove it and compress the circumference of the handle end with light hammer blows. Then fit the ring farther down the handle and hammer on the end until the wood returns to its original girth.

Japanese chisels usually need to be polished and tuned when purchased. Over time they will dull and need to be resharpened. See the section below on polishing stones.

Specialty tools. Certain hooked and curved chisels are made especially for cleaning up the sides, bottoms, and corners of tiny shoji mortises. Whether or not you have any other Japanese tools, you will find these small specialty chisels (*morinomi, sokosarae, yarinomi,* and *kannanomi*) especially useful.

Hammers. Japanese chisel hammers have two faces. One is flat, the other convex. The flat face is used for driving pins and nails. The convex face is used only for hitting the chisel handle and for making final hits on nails and pins so as not to damage the surrounding wood surface. The bulge in the center of the convex face helps mushroom the wood over the ring on the end of the chisel.

The weight of the hammer should reflect the scale of the joinery. For large timber joinery a heavy hammer is needed, but for lightweight shoji a 185-gram (6.6 oz.) hammer is more appropriate. Remember that a sharp chisel doesn't need to be struck as hard as a dull one.

Hammers for adjusting plane blades are small and compact, either hexagonal or barrel shaped, and are used to apply a concentrated light tap that fine-tunes the setting of the plane blade in the plane body.

CUTTING A MORTISE

This section explains how you can use a chisel to make a through mortise in the stile of a shoji screen. See part 3 for a fuller explanation of layout and assembly.

Step 1. Make stop cuts ⅛" deep just inside (1/32") the layout lines at both ends of the mortise (a and b; fig. 1). Stop cuts prevent the chisel cuts along the grain from removing wood or splintering beyond the layout lines. With a chisel or marking gauge, lightly score both sides of the mortise (parallel to the grain) just inside layout lines c and d.

Step 2. Using a hammer and chisel, begin removing wood by starting a shallow V-groove across the grain at the midpoint of the mortise (fig. 2). The beveled side of the chisel blade should be face down (that is, the hollowed-out face should be facing away from you). The angle of the chisel cut will be the same as the angle of the bevel in relation to the wood. Make angled cuts as shown, gradually moving the starting position of the top of the cut from the midline of the mortise to the initial stop cut. The bottom of the deepest cut should be half the depth of the mortise. Now turn the stile over and repeat from the other side until you can punch a hole through the center interior of the mortise, leaving two wedge-shaped sections of wood.

Step 3. Now, controlling the chisel with your hand (use a paring chisel if you wish), shave the wood on the interior of the mortise back to the shoulder on each side. Make your cuts with the grain, beginning at an angle less than 90° to the top face of the mortise and coming closer to perpendicular as the sides become flatter (fig. 3). Work from both the top and bottom.

Step 4. Clean up all irregularities on the interior faces of the mortise with a sharp tool or with the specialty shoji chisels described above. Bring all surfaces to their full margins according to the original layout lines. Leave half the thickness of the layout line visible (to match with the half-thickness that will remain on the tenon and insure a good fit; see the section on saws, below).

Kumiko mortise. A blind mortise only ¼" deep is used to connect the kumiko to the frame. When making this mortise, be sure to make very clean cuts so that the shoulder is not distorted by the tenon when the shoji is assembled. Reverse the position of the chisel here, keeping the beveled side up, away from the wood; this will prevent the chisel from crushing the shoulder of the mortise as it enters the wood (fig. 4).

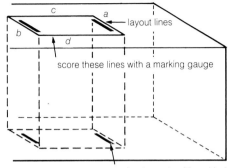

Fig. 1. Make stop cuts just inside the layout lines.

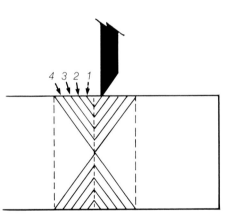

Fig. 2. Hold the chisel bevel side down. Start removing wood at the center and work toward the edge of the mortise.

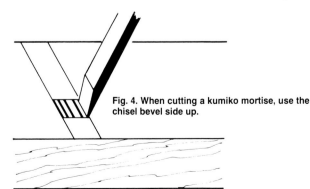

Fig. 4. When cutting a kumiko mortise, use the chisel bevel side up.

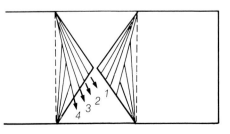

Fig. 3. Pare the wood back to the sides of the mortise. Clean and flatten all interior surfaces.

MAKING A SCABBARD
FOR A PARING CHISEL

The chisel work explained above can be done with Japanese butt and paring chisels in standard sizes. Some shoji work, however, may be too small and close for these tools. Narrow chisel blade stock is sold by many tool importers. Here is a simple way of making a scabbard for your fine paring chisel that will make it easy to hold and protect it in storage.

Assume the blade stock is 6" long by ⅛" high with a ¼" cutting edge (smaller blade widths of ³⁄₁₆" and ⅛" are also available). Take a square-cut piece of seasoned poplar or cedar that is 8" long by ½" thick by ¾" wide. Use *sumi* or a soft lead pencil to index the surfaces of the wood that will become the top and bottom. Draw a line continuously around the long circumference of the piece so that the top section is about ⅝ of the total thickness. Carefully rip cut this line.

Lightly plane each sawn surface to remove saw marks. Lay the flat side of the chisel onto the top, thicker section, leaving about 1" front and back. Trace around the chisel. Next rub *sumi* along the entire length of the bevel ridge on the other side of the chisel. Press the ridge onto the wood where you traced the flat side of the chisel. This will leave a visible mark on the wood indicating the area that will be carved the deepest.

Make stop cuts at either end of the tracing, and score the wood just inside the main chisel outline. Score more deeply inside the edge of the ridge marks. Now pare out the ridge marks to make a channel just less than ⅛" deep (the chisel height). Pare the channel's sides at the same angle as the chisel's sides until you reach the

edge of the chisel outline. To check your work, use *sumi* again on the chisel to indicate high spots that need to be fixed. You are done when the chisel sits in the channel without wobbling, its flat side flush to the wood surface. If you have cut too deep, lightly use a plane to reduce the height of the wood.

Now place the bottom section of wood over the carved side with the blade in place. Make sure both wood surfaces are flush. *Remove the chisel* and apply a light coat of white glue or rice glue to both wood surfaces. Don't let any glue get into the chisel channel. Use clamps or string to hold the scabbard together until the glue dries.

After the glue has set, remove the clamps or string. Cut through the scabbard at a point 3" in from the front. Clean the endcuts carefully.

Insert the back of the chisel gently but firmly into the handle end of the scabbard. Fit the front of the scabbard over the front of the chisel. *Slightly* wiggle the front piece side to side as you fit it on; this expands the channel slightly in front while creating a compression fit in back, helping prevent the back from coming off before the front when the scabbard is opened.

With the chisel in the scabbard, plane and chamfer the outside surfaces to a shape that is comfortable to hold and to use. In time, as you use and sharpen your chisel, it will shorten in length. To keep 2" of usable steel projecting from the handle, pull the shortened blade out of the handle and drill a hole where a small dowel or chopstick can be inserted across the channel as a new stop.

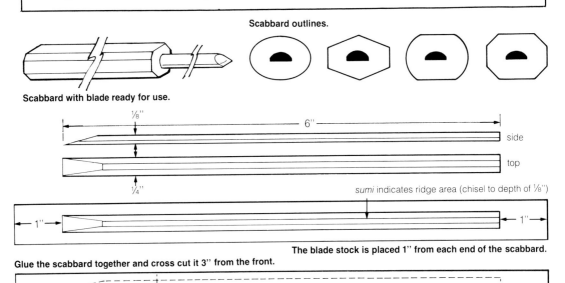

Scabbard outlines.

Scabbard with blade ready for use.

⅛" ⸻ 6" ⸻ side
top
¼" *sumi* indicates ridge area (chisel to depth of ⅛")

1" 1"

The blade stock is placed 1" from each end of the scabbard.

Glue the scabbard together and cross cut it 3" from the front.

3"

Planes

The tool used to square the wooden pieces that make up the shoji screen and to give them their lustrous surface is the wooden-bodied plane, called *kanna*. *Kanna* are of two types: smoothing (surface flattening) planes and polishing or burnishing (final finish) planes. The finer the degree of conditioning of the sole (the bottom) of the plane, and the smaller the distance between the cutting edge of the blade and the gliding surface just in front of it, the higher the degree of burnishing the plane can accomplish.

The Japanese plane is pulled along the surface of the wood using the power of the leg and torso muscles. It is guided by the wrists. In contrast, Western planes are pushed away from the body, and the grip on the handle is less responsive to the wood. The blade of the Japanese plane is routinely sharpened to the extent that it can shave hair like a razor. The smooth shear of the wood fibers by the razor-sharp blade combines with the friction heat of the gliding surface to burnish and seal in the wood's natural oils. Light is reflected cleanly from the wood, not scattered as it is when even a very fine sandpaper is used. One can almost see into the planed wood's cellular structure. This sparkling effect is unlike that obtained by any other finishing method. Wood finished with a Japanese plane requires neither sanding nor oiling.

ADJUSTING AND USING THE PLANE

The Japanese plane is an uncomplicated tool. It consists of a block of white or red oak for the body with a slot (throat) for a cutting blade that projects through from top to bottom. Like chisel blades, plane blades are made of hard and soft steels laminated together to provide maximum sharpness and shock absorption. Standard blades are set at 32–35° (45° for working with hardwoods). Usually there is a secondary blade, the sub-blade or "chipper," which helps prevent the wood from tearing as the shaving is taken up by the cutting edge.

Learning to use the Japanese plane takes practice and demands control over fundamental hand-and-eye skills. In time, as you use the plane, you will come to make your own individual adjustments in the conditioning of the block and the setting of the blade, as well as in your posture and grip as you work. The basics of

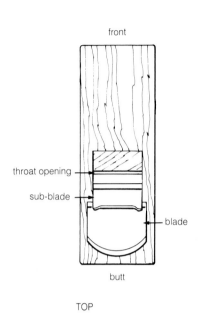

front

throat opening

sub-blade

blade

butt

TOP

Parts of the Japanese plane.

BOTTOM

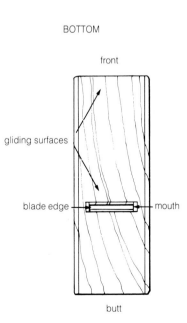

front

gliding surfaces

blade edge

mouth

butt

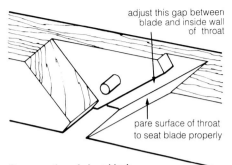

adjust this gap between
blade and inside wall
of throat

pare surface of throat
to seat blade properly

Cross-section of plane block.

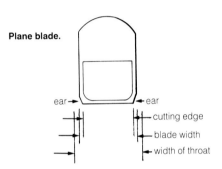

Plane blade.

ear → ← ear

cutting edge

blade width

width of throat

Exaggerated view of conditioned plane block.

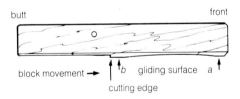

butt front

block movement → ↑ b gliding surface a ↑

cutting edge

Sub-blade assembly.

adjust flanges

make sub-blade flush with edge of main blade

using a Japanese plane are nevertheless straightforward. Here are some general pointers, which should be supplemented by a class or by further reading in the books cited in the Appendix.

Adjusting the throat. Plane blocks sometimes shrink or distort between the time they are made and the time they are purchased. Check to make sure the gap between the outside edge of the blade and the inside wall of the throat is not too tight: 1/16" is about right, just enough so that you can tap the blade from side to side to make it parallel to the mouth on the bottom of the plane. Use a small chisel to open the gap as needed.

The blade should get snug as its cutting edge nears the mouth. Push the blade into the throat by hand, and then give it five to ten light taps with a hammer to seat it. If you have to strike the blade harder than this to get it into place, the fit is too tight and you should adjust the back of the throat. First remove the blade (if it is stuck, remove it by hammering the chamfered top rear edge of the plane block at an angle *parallel* to that of the blade; as you do so, hold the blade with your thumb to prevent it from flying out). Now rub *sumi* ink, a soft pencil, or a felt pen evenly over the back of the blade. Reseat the blade in the block and tap it lightly with a hammer. Remove the blade and inspect the surface of the throat. Visible ink or pencil marks on the throat will indicate where the wood is high or uneven. Delicately pare these areas down with a chisel and try seating the blade again. Contact with the blade should be evident across most of the inside surface of the block. If by mistake you remove too much wood and the wedge-shaped blade doesn't tighten until too much of the cutting edge is exposed, shim the back block surface with a thin wood shaving or paper. Keep the bottom of the blade tight, and remember that the blade need only project from the mouth a few thousandths of an inch.

Adjusting the blade. The "ears" of the plane blade (that is, the outside corners of the cutting edge) may have to be ground down so that the length of the cutting edge is slightly narrower than the mouth opening. If the blade is too wide in the throat, wood cut on the excess will jam up and prevent the rest of the shaving from exiting. Use a power water grinder. Trimming the ears like this is usually done with a new blade or as part of normal maintenance about once a year.

Adjusting the block. The body of the plane requires regular conditioning. The sole of the plane is designed to contact the wood along two flat and parallel gliding surfaces. The first gliding surface (*a*) is at the very front of the sole. The second surface (*b*) lies just in front of the cutting edge of the blade. All other areas on the sole are made slightly concave to these gliding surfaces; the recess on rough planes—$\frac{1}{32}$"—is greater than on finishing planes, which are *almost* flat in the areas between the gliding surfaces. The gap between gliding surface *b* and the cutting edge is very slight—less than $\frac{1}{32}$"—on a finishing plane. It is this proximity of blade and pressure that creates the burnished effect on the wood. Check the sole with a straightedge and repair any unevenness with a scraper plane. Since the pressure of the blade in the throat creates a slight bulge in the bottom of the plane behind the mouth, always keep the blade in place when checking and conditioning the sole. Be sure to recess the blade slightly to prevent it being damaged by the scraper plane.

The sub-blade. The edge of the sub-blade should be positioned as close to the cutting edge of the main blade as possible, less than a thin pencil line. It must also be perfectly flat along the main blade; otherwise shavings will build up between the two blades and clog the throat. Hold the blade and sub-blade in position against each other and look at them from the back to see if there is a gap that lets any light through. Flatten the bottom of the sub-blade as necessary. Then adjust the angle of the flange on the sub-blade by hammering it on a metal plate to eliminate any uneven points of contact.

Getting started. After the blade has been sharpened (see the section below on polishing stones), set it in the throat of the plane and lightly tap it into place. Make sure the edge of the blade is parallel to the gliding surfaces. Hold the plane in one hand and sight along its body from the front, carefully judging the extent to which the blade projects beyond the plane of the gliding surfaces on the bottom of the block. The greater the projection, the thicker the shaving. Remember that the shaving should be the same thickness across the width of the blade once the board itself has become flat and true. A rough shaving should be $\frac{5}{1000}$" thick, while a final burnishing shaving will be $\frac{1}{1000}$" or thinner. With a small hammer, adjust the position of the blade as needed.

When using the plane, hold it (assuming you are right-handed) in your right hand between the blade and the front of the block. The right hand controls pressure and direction. The left hand controls the area beyond the blade toward the butt. Apply even pressure along the entire length of the stroke.

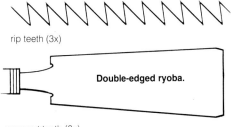

rip teeth (3x)

Double-edged ryoba.

crosscut teeth (3x)

Dozuki saw with smaller, finer crosscut teeth.

(6x)

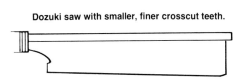

Fig. 1. Rip cut along lines *a*, *b*, and *c*. A shallow groove along the entire length of *a* keeps your saw in line.

c

d

a

b

Fig. 2. Saw along *a* until the cut reaches from the near shoulder to the opposite bottom corner. Turn the piece over and repeat.

Now insert the sub-blade, tapping it into place. Recheck the position of the main blade to make sure it has not been disturbed.

Always determine the grain direction of the wood before starting to plane. Plane with the grain, not against it, laying down the fibers instead of picking them up. Watch for debris and irregularities in the wood, such as knots or pits, that need special attention. Don't try to take too thick a shaving at one time. Thinner shavings are easier to produce and safer for the wood.

Saws

While Western saws cut on the push stroke, Japanese saws (*nokogiri*) cut on the pull stroke. Advancing the cut toward you always gives you more control over the action of the saw. Because the work of the Japanese saw is done with tension on the blade, the steel for the blade can be made thinner and harder, resulting in a finer kerf (blade thickness and tooth set determining the width of wood removed with each stroke) and thus a quicker and cleaner line of cut.

The standard saws used by Japanese carpenters are the *ryoba* and the *dozuki*. The ryoba is double-edged, with crosscut teeth (for cutting across the grain) on one side of the blade and rip teeth (for cutting with the grain) on the other. The dozuki has a single cutting edge with a very thin blade supported by a backing ridge. It is used for very fine cuts and is available in both rip and crosscut styles.

The length of the ryoba blade generally determines the size of the teeth; longer saws (270–300 mm, or 10½–12") will have coarser teeth than shorter saws (130–150 mm, or 5–6"). On each saw, the rip teeth are smaller toward the handle and become larger toward the front. Always start your rip cuts with the smaller teeth and finish with the angled foot on the front of the blade, which represents the angle at which the saw cuts most efficiently. This angle is very low when compared with a typical Western push saw.

CUTTING A TENON

Here is how to cut a simple corner tenon in the rail of a shoji frame. See part 3 for a fuller explanation of layout and assembly.

Step 1. Make all rip cuts first along lines *a*, *b*, and *c* (fig. 1). Start by making a light groove on the top corner of *a*, leaving half of the thickness of the layout line on the wood (another half-thickness appears around the mortise; see the section on chisels, above). Rotate the wood so that the opposite face is up. Working on the same line *a*, start a new cut with the fine teeth and saw down the end face of the wood to connect with your initial cut. This gives you a shallow kerf, square with both surfaces, to help you guide the saw blade as you advance to the shoulder of the tenon.

Step 2. Position the wood so that the end of the tenon is facing away from you. Saw along *a* until the cut reaches from the near shoulder to the opposite bottom corner (fig. 2). Repeat on the opposite face.

Step 3. Now return the rail to its original position. Facing the end, with the saw perpendicular to the end surface, saw through the kerf until the rip cut reaches completely to the tenon shoulder. Be careful not to oversaw the shoulder (fig. 3). Repeat for *b* and *c*.

Step 4. Now begin the cross cuts. This will remove all waste and establish the tenon shoulder. Using your finest crosscut teeth, start a light kerf on the waste side of the shoulder layout line at *e*. Cutting toward you, advance a shallow cut from *e* to *f* (fig. 4). Rotate the wood one face and continue advancing the shallow kerf from *f* to *g* and then from *g* to *h*.

Step 5. Once the kerf is continuous around three sides of the wood, work through two sides at corner *f* until the crosscut kerf approaches the rip kerf (fig. 5). Use the initial shallow kerf you made to keep the saw aligned at 90° to the surface of the wood. As the crosscut kerf approaches the rip kerf, the sound of the cutting becomes softer. Watch and listen carefully, and make sure you end your cross cut without over-sawing the rip cut and weakening the tenon. Continue cutting around the tenon at *g* and *h*.

Step 6. Now remove all the waste between the rip cuts. Check each face for bulges, warps, twists, and other irregularities. Use a paring chisel to correct them. Don't try to make the surface of the wood too smooth, since the tenon will fit more snugly in the mortise if its surface is slightly scored from the saw teeth.

Fig. 3. Saw through the wood from the end until you reach the shoulder.

Fig. 4. Make shallow kerfs connecting points *e–f*, *f–g*, and *g–h*.

Fig. 5. Start at *f* and cut through to the previous rip cuts. Watch the depth of the cut along the face that contains the base of the tenon (line *h–e*).

#800 grit artificial stone.

#1200 grit artificial stone.

Natural rough stone.

Polishing Stones

A sharp tool is better than a dull one, no matter what the brand, where it came from, or how much it cost. The precise fits and rapid execution of wood joints can be obtained only with the sharpest of tools. A shoji maker therefore must come to possess a more than adequate sharpening skill. Sharpening itself becomes a discipline to be practiced with patience, perseverance, and care. The reward over time is a gradual increase of speed and accuracy in the work.

Polishing is an abrasive action and is a much more refined task in the Japanese tradition than in its Western counterpart. Japanese polishing stones, called *toishi*, contain clay and use water as a lubricant to flush away the metal and paste produced as the blade is sharpened. Unlike Arkansas stones, which contain no clay, Japanese stones should never be used with oil.

Japanese polishing stones come in both natural (quarried) and artificial (usually baked silicon carbide) varieties and are broadly grouped into three grades, each one progressively finer. The stones are used in combination. To polish a very dull or nicked tool, for example, you begin with a rough stone, move up to a medium stone, and hone the blade with a fine finishing stone. Daily maintenance sharpening can usually be done with just a medium stone followed by a finishing stone.

Natural stones within the same category show great variation. Each tool, too, because of its unique quality and hardness, may require a separate polishing regimen. Experience is your only guide to what combination of stones is appropriate in each polishing situation.

TYPES OF STONES

Rough. Rough stones, called *ara-to*, are from #32 to #400 grit and are used to shape the blade or, in the case of a very dull or chipped blade edge, remove

Natural medium stone.

metal quickly. Their use results in very obvious scratches on the metal and in a significant burr or wire edge forming on the flat side of the blade (the side opposite the beveled surface that is in contact with the stone).

Medium. Medium stones, called *naka-toishi*, range from #600 to #1500 grit and are used to remove the scratches and the burr left by the rough stones. A #1200-grit artificial stone is adequate for most purposes, but some craftsmen also like to use a natural "medium-finishing" stone, or *nakashiage-toishi*, that is somewhat finer (up to #2000 grit). The well-known *ao-toishi*, or "blue stones," in this group are quarried from the mountains around Kyoto, while *tsushima-toishi*, popularly known as "ocean blue stones," come from Tsushima Bay near Nagasaki and are harder than the Kyoto blue stones. *Nagura* stones from Mikawa can be used just before finish polishing. A good medium stone works quickly and produces a satin surface and more delicate wire edge on the flat side of the blade.

Finishing stones. These very fine stones, called *awase-toishi* or *shiage-toishi*, can range from #1500 to #8000 grit and have no peer among Western stones. A blade polished on a medium stone is sharp enough to use. A natural finishing stone further hones its edge, removes the light burr on the flat side, and, in the hands of an expert, reveals the quality and texture of the steel. (Artificial finishing stones produce a more mirrorlike surface.) The very finest stones are the true "Honyama" finishing stones from Kyoto. These can cost $900 or more (many suppliers offer cheaper, generic "Honyama" stones that do not come from the original quarry). Such an expensive stone would be of use only to a real expert. Lower-grade natural finishing stones are adequate for most applications and are available from about $35. Artificial finishing stones are sold under the names Aquastone, King, Lobster, and Bester.

Natural blue stone.

Natural *awase* finishing stone.

Natural *awase* finishing stone.

Listen carefully as you polish. A stand for a polishing stone has a hollowed-out base to amplify the sound of the blade.

Chamfer the top edges of the stone and make sure its working surface is perfectly flat. Water on the stone should lie evenly over the entire surface.

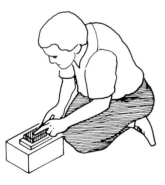

Kneeling position of polisher at work.

The polishing stroke.

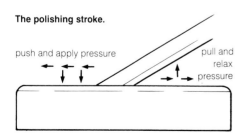

push and apply pressure

pull and relax pressure

ABOUT POLISHING

Your sharpening area should be well lit, but out of direct sunlight, and free of dust, grit, and debris. Good light helps you see the result of your work, while a clean space eliminates contamination and possible damage to stones and tools. It helps to have your workplace quiet, too, since the sound of metal on stone can be a valuable aid to judging whether the pressure and angle of the blade are correct. A wooden support stand helps amplify the sound and holds the stone steady as you work.

If using a new stone, first chamfer its edges to prevent them from chipping off or cutting you as you polish. Then examine the surface of the stone. To sharpen a straight-edged cutting tool like a chisel or plane iron, the stone must be perfectly flat. If it is not, rub it across #150-grit wet/dry sandpaper on a true-flat surface such as a slab of marble or laminated safety glass. The stone is ready when a thin sheen of water remains over the entire surface and does not puddle in spots or in the middle.

Rough artificial stones must be soaked thoroughly in water before they can be used. Put your stone in a pail of water and wait until it stops bubbling, about five or six minutes. While you polish, apply more water to the surface of the stone as needed. Water acts as a lubricant and flushes away the metal build-up on the stone. Finer artificial stones can be soaked but need not be. They do not bubble like rough stones.

Natural stones should not be soaked. Place the natural stone face down on a wet surface like a moist paper towel and keep it there for a few minutes before you begin polishing. To protect the stone from excess moisture, paint or lacquer all but the working surface. Always store the stone out of sunlight and wind; quick drying could cause the delicate stone layers to separate. Never keep the stone where the air temperature drops below freezing, or it will crack.

Japanese tool polishers kneel on the floor as they work. While uncomfortable at first, this posture gives the body a lower center of gravity and helps prevent swaying or weaving that might result in an uneven polish. In this posture, and with the stone on a stand in front of you adjusted to a height between 6" and 10", you should be able to comfortably reach to the end of the stroke. Pressure on the blade should come from the upper body alone. Hold the blade firmly, but do not force it onto the stone. Pressure is transferred through

the fingers on the push stroke. This pressure is relaxed on the return stroke as the blade floats back over the glaze of water on the stone.

BASIC POLISHING TECHNIQUES

The polishing techniques outlined here will work for both chisel and plane blades. They assume you will be using three (or more) stones in sequence, although in most cases two stones will suffice for maintenance sharpening. You will have to remove the plane blade from the plane block, but should keep the chisel blade attached to its wooden handle. Before sharpening a chisel, check to make sure the cutting edge is square to the handle. Do this by holding the chisel blade between two fingers and letting the handle hang free. If the edge is not square, your chisel cuts won't be either, and the two entry walls of the mortise will not line up. Adjust an irregular chisel by dragging its cutting edge lightly across the surface of a medium stone until it is square. You can also remove small chips in the blade this way.

If the angling in a blade is a result of your own sharpening efforts, the problem probably lies in your grip, and particularly in the way the torque in the action of your forearm muscles is transferred to the cutting surface of the blade as it moves across the stone. To compensate, slightly rotate your grip position on the handle in the opposite direction.

Do not rock the blade as you push and pull it across the stone or the edge will become round and snubbed: keep the bevel flush with the surface of the stone at all times. Use slightly more pressure when polishing the beveled side of the blade, since this is where the hard, high-carbon steel is located. This steel cuts slower than the blade body's softer, low-carbon steel, which would wear away quickly under the same amount of pressure. Should the softer steel wear excessively, the bevel will flatten out and, at this lower angle, may fail to support the cutting edge. For this reason, keep the angle of sharpening constant (unless it is your specific intention to change the angle of the blade, as it might be with a plane designed for a particular job or type of wood).

Plane blades are made of steel that is somewhat more brittle than chisel blade steel, and may require a different polishing stone or sequence of stones.

Step 1. Begin with a thoroughly soaked artificial stone. A stone of #1200 to #1500 grit is adequate for

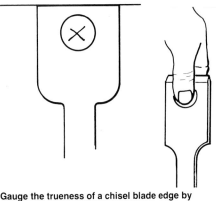

Gauge the trueness of a chisel blade edge by dangling it between your thumb and forefinger.

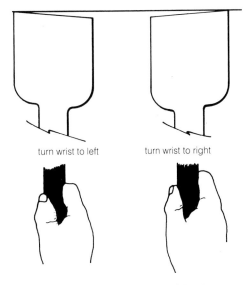

turn wrist to left turn wrist to right

If the blade does not sharpen to a straight edge, try turning your wrist to adjust your grip on the handle as you polish.

Keep the bevel of the blade completely flush to the stone. Avoid the tendency to rock the blade upward on the return stroke.

Polishing the cutting edge (beveled side).

Removing the wire edge on the flat side of the blade.

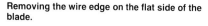

How to hold a plane blade for polishing.

How to hold a chisel blade for polishing.

Polishing the cutting edge of a blade produces a fine wire edge on the opposite face.

most maintenance sharpening. For a chisel or plane blade with a chip or a nick, use a coarser stone (#400 grit) or a machine waterstone grinder. Hold the blade or tool with both hands as shown in the illustration, the beveled edge of the blade flush to the surface of the stone. Apply pressure only on the push or sharpening stroke, relaxing on the pull stroke.

Do not rock the blade as you return your stroke. Use all the surface of the stone, not just the area in the middle; otherwise the stone will quickly become out of flat. Continue passing the blade over the stone until a burr or wire edge appears on the surface opposite the cutting edge (that is, the top or flat side of the blade, with the hollow grind). The polished surface of the metal at this point should look evenly scratched. As you polish, the sound of the metal on rough stone will be loud and coarse.

Step 2. Switch to a medium-finishing stone. Turn the blade over and place the hollow-grind side of the blade flat on the stone. Push the blade lengthwise several times, rapidly and firmly, until the wire edge left by the previous stone disappears. Now continue polishing this flat side until an even sheen is created over the entire area between the cutting edge and the hollow grind. This area should not exceed ⅛" in width. You would not normally polish this area on a rough stone unless the blade needs a major repair, such as when the edge wears into the hollow grind of a chisel and loses its straightness.

Now turn the blade over again and polish the beveled side until all scratches of the previous, rougher stone disappear. A new, much finer burr will begin to appear on the flat side of the cutting edge. The sound of this medium-finishing stone is deep, but softer and less harsh than that of the rougher stone.

Step 3. For the finish polishing, you will have to experiment to find the combination of tools and stones that work best for you and for your tools. Whatever stones you use, begin by polishing the flat side to remove the burr and scratches left by the medium-finishing stone. Then polish the beveled side of the blade. If you use more than one finishing stone, work in order of increasing hardness. Combinations of hard stones with softer steels and soft stones with harder steels yield different results that can only be understood and controlled through experience. The sound of these finishing stones is very quiet. Always judge your results by the luster of the blade and especially by the quickness of the tool as it cuts through wood.

A tree branch placed in a shoji lattice above a rough-hewn bench gives this elegant Japanese room the flavor of a rustic farmhouse. Otomoro, Kanazawa.

MAKING A SIMPLE SHOJI SCREEN

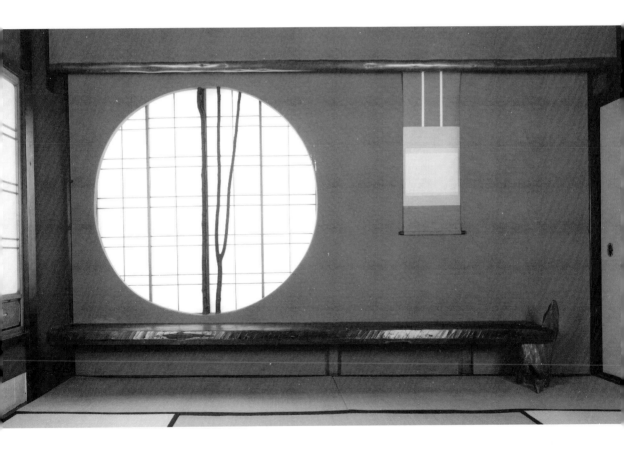

Planning

This section explains how to make a simple 24" by 36" shoji screen of the sort that can be used singly as a window insert or as part of a multiscreen installation. See part 4 for design and installation ideas. You will probably not need a shoji in exactly the dimensions given here, but the methods of figuring sizes, of estimating the amount of wood to buy, and of indexing, cutting, and assembling the pieces will work for most of the shoji screens you can make. Before beginning your own project, think carefully about what your screen will look like and how it will be used. Pay special attention to the following factors when planning out your work, be it a single screen or a multiscreen installation. See part 2 for a more detailed discussion of materials and installations.

1. *Number of screens*. Fit the number of panels to the site, both aesthetically and functionally. Narrow panels are sturdy, but for a given opening you need more of them, and this can result in a busy design or too many tracks. Larger panels may sag unless they are properly supported and framed. Having an odd number of panels will make it impossible to store the screens in equal-size stacks on either side of the pass-through.

2. *Tracking mode*. A shoji can slide in grooves at top and bottom, hang from a track, or be fitted with hinges. With tracks, part of the pass-through will be obstructed when the shoji are open unless the tracks feed into a pocket in the wall or extend beyond the door or window frame. Always check manufacturers' recommended dimensions and tolerances if you are using hardware for hanging or hinging.

3. *The opening*. In many homes, door and window openings are out of plumb. A perfectly square shoji will not fit here. You can either adapt the shoji to the irregular opening or, better, make a wood insert that will bring the opening into true again. The insert can be hidden behind a piece of trim or molding. Also consider whether a space can be opened up between the walls on either side of the opening to create a pocket to hold the screens.

4. *Kind of wood and finish*. Select wood according to color, structural integrity, surface grain, durability, cost, availability, ease of working, and how well it matches other materials in the house or room. Japanese planing brings out the natural sheen of the

> *No amount of planning will produce the desired results unless you keep two things firmly in mind: measure everything exactly and keep your saws, planes, and chisels sharp.*

wood, but oil treatments will protect the finish and bring out the grain. Dark staining may help blend the shoji into a modern interior. Light-colored woods help brighten up the room.

5. *Assembly*. Consider your aptitude for details, your patience, and your control over your tools before beginning complex projects. Among the most common shoji are single-lattice shoji, double-lattice ("sandwich") shoji, shoji with a wood panel at the base (for stability), and shoji with sliding, windowlike panels. Joinery can be both aesthetic and functional. The screen presented on the following pages uses a through tenon with wedges, which is strong, attractive, and relatively easy to make.

6. *Lattice design*. The rectangles formed by the vertical and horizontal kumiko are one of the most distinctive features of shoji design. Consider these patterns in relation to the shape of the room and the opening. A long, narrow opening, for example, might look good if that same proportion is echoed in the lattice.

7. *Facing materials*. Paper and fiberglass are the materials most commonly used. Paper filters light better and offers more interesting sensory effects, but its fragility usually makes it unsuitable for high-traffic American homes.

The finished screen, with alternating kumiko.

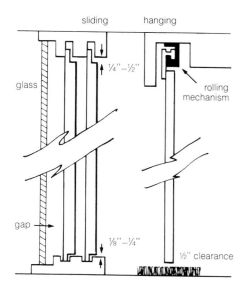

sliding hanging

glass

gap

$\frac{1}{4}" - \frac{1}{2}"$

rolling
mechanism

$\frac{1}{8}" - \frac{1}{4}"$

$\frac{1}{2}"$ clearance

**When measuring, be sure to figure in all tracking
mechanisms and manufacturers' specifications.**

Deriving Overall Measurements

The dimensions of the shoji are figured by taking into account—in addition to the size of the opening—the tracking devices, the door jambs, and the window sills. Measure the opening carefully to determine whether it is square and straight. Also decide what kind of tracking mechanism to use. Tracks can be built into existing sills, but this may not be advisable for temporary installations. Adding tracks atop existing frames obviously shortens the height of the shoji frame, while casters, wheels, and other tracking mechanisms have specific tolerances that must be added in to your reckoning. The width (thickness) of the screens is limited by the depth of the opening, although the opening can be extended by a liner box insert or other device. When the screens are closed, they should overlap each other by exactly the thickness of one stile.

a: $(93" + 1\frac{1}{2}") \div 2 = 47\frac{1}{4}"$

b: $(93" + 3") \div 3 = 32"$

c: $(93" + 3") \div 4 = 24"$

d: $(93" + 4\frac{1}{2}") \div 4 = 24\frac{3}{8}"$

To determine the width of an individual screen in an installation, the opening width plus the sum of the overlaps is divided by the number of screens. The relationship between the sizes of the individual screens and the width of the opening should be a mathematically simple one. Try to find configurations that yield numbers easy to work with. Here we assume the opening is 93", with each stile 1½" wide. Stiles must overlap each other exactly.

How Much Wood?

The amount of wood for each part of your shoji should be figured from a finished design sketch. Draw the sketch to scale so that you can accurately figure proportions and measurements. Don't forget to allow for hidden tenons and tracking devices. For the sake of demonstration, the calculations here assume that our 24" by 36" shoji will be part of a four-screen installation similar to c shown on this page. We add 30 percent to allow for the waste in resawing and joining and for making extra pieces to replace those that warp, break, or don't fit. Add more or less depending on the quality

of the wood and the complexity of the job. Having too many pieces is far preferable to not having enough and being forced to buy more wood and remeasure. Be especially careful when working with small pieces of brittle woods like Douglas fir or oak.

After determining how much wood you need, the total should be calculated in board feet. Most shoji should be cut from well-seasoned "two-by-six" (actual size 1½" by 5½") pieces of lumber. These work better than standard "one-by-twelve" (¾" by 11⅜") boards, whose broader sections make them more likely to warp. In the example here, one 6' two-by-six will provide enough wood for a single screen, assuming all of it is usable.

Amount of wood needed for four 24" by 36" shoji screens in a multiscreen installation.

rails (1¼" × 2½"):
24" length × **2** rails per screen × **4** screens = **192"** × 130% = **250"** (**21'**)

stiles (1¼" × 1½"):
36" length × **2** stiles per screen × **4** screens = **288"** × 130% = **374"** (**31'**)

horizontal kumiko (¼" × ⅜"):
21½" length × **4** kumiko per screen × **4** screens = **344"** × 130% = **447"** (**37'**)

vertical kumiko (¼" × ⅜"):
31½" length × **3** kumiko per screen × **4** screens = **378"** × 130% = **491"** (**41'**)

Total wood needed should be calculated in board feet.

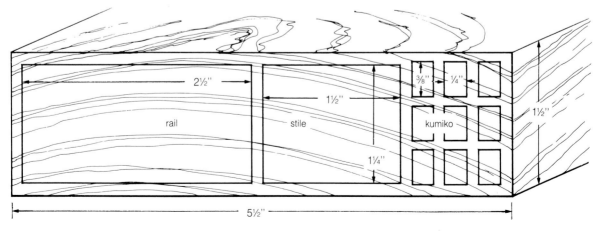

2½"

rail

1½"

stile

⅜" ¼"

kumiko

1½"

1¼"

5½"

Always cut square pieces from oversized lumber.

True the surfaces of the wood in sequence.

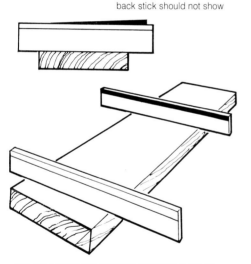

back stick should not show

Winding sticks will show where wood is out of plane.

bad acceptable

Shoji can be made with bowed wood (exaggerated view).

Milling, Squaring, and Inspecting the Lumber

Lumber you buy from a vendor will probably not be the size you need for your shoji. It is always more economical to buy larger pieces and cut them down yourself rather than have the lumber yard or cabinet shop do it. Milling is best done on a table saw or band saw. Square the lumber first, and cut lengths as long as is practicable. Consistency and accuracy are important here. Make your cuts slightly oversized to allow for joining and planing.

Once the lumber is milled, cut it into lengths that approximate the pieces you will need. Now check each piece with a square and join it for straightness. Start with the best corner and plane the adjacent sides flat and true; work from these sides in sequence to establish a square cross-section. Using your plane, work on the rails and then on the stiles to make sure that similar pieces are all of uniform shape and dimension.

This preliminary work on the lumber is extremely important. A shoji with any of its members out of true will not assemble properly or move smoothly in its tracks. Now is also the time to appraise the wood for ease of working and to examine it for defects. Only wood that is sound, free of knots and pith, should be used from this point forward.

Beware of twists, warps, and bows. Inspect the wood carefully with winding sticks, two parallel edges that exaggerate surfaces out of plane. Pieces that are slightly bowed can be salvaged if the bows are oriented to the interior of the screen. An exterior orientation will pull the kumiko out of their joints, while a lateral orientation (that is, to front or back) may cause the wood to bind in its tracks or wedge against its neighbor.

It is at this point that one understands the false economy of purchasing inexpensive lumber. High-grade, seasoned lumber costs more per board foot, but this always pays off because more of it is usable. Skimping on materials indicates a poor attitude to the job you have set for yourself, an attitude that will certainly not improve as work progresses and you find yourself fighting the wood rather than working in harmony with it.

Preparing the Frame

Having trued all the wood you can now decide which surfaces will be used for the front and back of the shoji. Particularly with single-lattice screens, always choose the best surfaces for the front (that is, the visible) surface of the shoji. Lay all the rails side by side and hold them together with light clamps that will not mar the wood. Do the same with the stiles, making sure that all the fronts, backs, and sides are properly aligned.

Cut the rails and stiles to "working length," which is slightly longer than the final length so as to provide the wood with extra strength in the areas where the joints are being made. In the case of the rails, the working length is 25" (24" plus ½" on each end); for the stiles it is 37". Now mark (index) each piece's proper orientation. Whether you use pencil or a Japanese ink marker, be careful not to mar or leave any indents in the surface of the wood. A single mark on what will be the inside of the frame at the same time indicates front, back, and outside. With multiscreen installations, indexing marks are absolutely necessary to keep all the pieces in alignment over the course of the job, from measuring the dimensions to cutting and final assembly. Planing before assembly removes the indexing marks.

Note: Always keep your work surface free of wood chips and sawdust that can scratch or pit the smooth surface of the wood.

MEASURING THE RAILS

Note that the tenon on each rail is located toward the inside of the frame. With the rails still clamped together, measure along the indexed surfaces according to the diagram here. The final length of the tenon will be the width of the rail, or 1½". Don't forget the ½" extra you've added on to each end to make it easier to work.

Remove the clamp from the rails. Using a square, draw straight lines completely around the pieces to serve as cutting guides. Mark the height of the tenon along the front and back of the rail. Use a marking gauge to mark the width of the tenon on the end and on the top and bottom of the rail. The tenon will be inserted in the middle of the stile. In the example here the tenon is ½" wide (leaving ⅜" front and back). Do

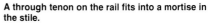

When working, make sure all indexing marks are aligned.

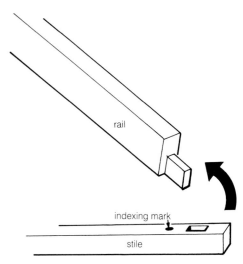

A through tenon on the rail fits into a mortise in the stile.

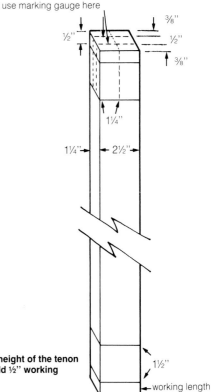

Mark the rails for cutting. The height of the tenon is half the height of the rail. Add ½" working length on each end.

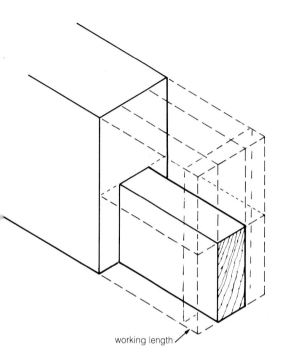

Cutaway view of tenon and measured rail. For information on cutting the tenon, see part 2.

working length

The tenon is offset when the stile is wider than the rail.

not readjust the marking gauge after you have set it for the tenons, since you will need the same setting for marking the mortise widths on the stiles. Always use the gauge consistently from the same side of the wood. Note that the surfaces of the shoji's rails and stiles must be in the same plane on the back of the frame so that the paper or fiberglass can be applied. If the depth* of the rail is less than the depth of the stile, the tenon can be placed slightly off-center on the rail so that the back surfaces line up properly.

Now mark the rails TL (Top Left), TR (Top Right), and so on. Put an X where wood is to be removed.

MEASURING THE STILES

Using the diagram here, follow a similar procedure as for the rails, this time using the marking gauge to indicate the position of the mortises on the inside and outside of the frame. The height of the mortise is half the height of a rail, or 1¼". Make sure the marks on the rails line up exactly with the marks on the stiles. Be careful that the scoring from the marking gauge does not extend beyond the layout lines where it will be visible on the final assembly. The mortise width should be marked at ½" to accommodate the ½" tenon: cleaning up the cut later will create a snug but slightly looser opening on the sides of the mortise so the tenon can slip in without being forced. Index TL, TR, and so on, and place the marked rails and stiles flat on the workbench in the order they will fit when assembled. Check for alignment once more.

CUTTING THE STILES AND RAILS

See the discussions "Chisels" and "Saws" in part 2 for an explanation of how to cut mortises and tenons. Cut the stiles and then cut all the rails, since the rails are easier to correct. Now and then test the fit of your pieces. Do not shorten the pieces from their "working lengths" yet.

*Here, "depth" in reference to rails, stiles, and kumiko refers to the dimension extending from the front toward the back of the screen.

To give the assembled frame joinery strength and stability, tapered wedges will be inserted into kerfs sawed in the ends of the rail tenons. The wedge is usually of a harder wood than the frame, and its different color creates a pleasing visual effect when the screen is viewed from the side. Make a narrow saw kerf in the rail tenon at a slight angle from near the outer edge toward the center, about half the width of the stile. Then use a chisel to flare the opening of the stile mortise ⅛" at top and bottom on the outer edge, working across the grain to about the midpoint of the stile. When the wedges are inserted at final assembly, the tenon will gently spread and create a dovetail joint in the mortise.

Use your sharpest chisel to clean the cuts. Do not overdo it, as the joints should be snug but not too loose. Before cutting the kumiko for the lattice, try assembling the rails and stiles. Use several light taps of a round-headed hammer with a wood block as a cushion when fitting the pieces together. Check to make sure that the outer surfaces are in the same plane and that the joints are square.

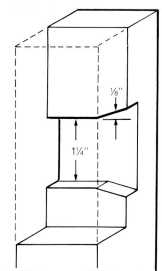

Make saw kerfs in the tenons and flare the outer openings of the mortises ⅛" for wedges to be inserted after final assembly.

Cutaway view of mortise and measured stile. For information on making the mortise, see part 2.

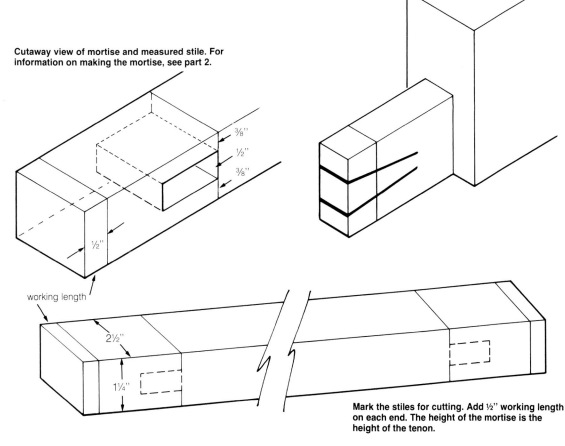

Mark the stiles for cutting. Add ½" working length on each end. The height of the mortise is the height of the tenon.

Preparing the Lattice

You will use four horizontal and three vertical kumiko for the shoji screen. Each kumiko measures ¼" wide by ⅜" deep in cross-section. These strips will be woven alternately under and over each other in a system of half laps. Similar to fabric weaving, this configuration gives the lattice strength and-stability. Other woven (or nonwoven) patterns can be used if the wood is difficult to bend and weave.

The kumiko are fitted into the frame using a blind mortise and tenon—that is, a tenon that does not pass completely through the joint—to a depth of ¼" in the rails and stiles. The back surfaces of the kumiko are flush with the back surfaces of the frame so that the facing material can be glued on flat.

Four kumiko lapping patterns.

flat weave

alternate lap weave

alternate stick weave

two-stick weave

LAYING OUT THE KUMIKO

Measure carefully! Once again, inspect the wood you will use for the kumiko. Cutting the half laps and assembling the lattice will put the kumiko under stress, and any flaws in the wood may cause it to snap or distort.

Cut the four horizontal kumiko to 21½", which is the length plus ¼" on each end for the tenon that will fit into the stile. (If you wish, leave a little extra on the ends to help support the wood when cutting the tenons; the illustrations here, however, show final lengths.) Similarly, cut the three vertical kumiko to 31½".

Take the rails and stiles you have made and, without joining them together, arrange them on a flat surface just as they will fit on the final screen, front side up. Now take the unfinished kumiko lengths and lay them out in the center of the frame, "weaving" the sticks in the same configuration you will use for the lattice. Index all the parts as shown in the illustration, marking the insides of the frame and the ends of the kumiko. Mark the left fronts of the horizontals and the top fronts of the verticals with dots so that you can keep track of their orientation. Mark the approximate positions of each half lap with an X where the kumiko cross.

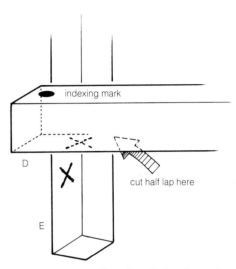

Put an X on each surface where the kumiko meet to indicate where the half laps are to be cut.

Exploded view of screen. Index front top or front left surfaces of all kumiko and inside surfaces of frame members.

vertical	horizontal
$4a + 3(0.25) = 21''$	$5b + 4(0.25) = 31''$
$4a + 0.75 = 21''$	$5b + 1'' = 31''$
$4a = 20.25$	$5b = 30''$
$a = 5.0625 = 5\frac{1}{16}''$	$b = 6''$

Calculating vertical and horizontal kumiko spacings. Each kumiko is ¼" (0.25") wide. Occasionally a layout for kumiko will not be regular due to unequal parts of divided fractions.

Clamp the rails and stiles together and mark the kumiko spacings. Make sure all indexing marks line up. Hint: when you have many rails, stiles, and kumiko to make of the same dimensions, mark the spacings on a single stick you can use as a template to measure all the pieces.

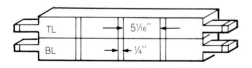

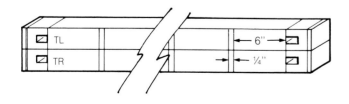

MARKING THE RAILS AND STILES

The positions of the kumiko mortises can now be marked on the rails and stiles. In the formula shown with the diagram here, if a is the distance between each of the three vertical kumiko and 0.25 (¼") is the width of each kumiko, then $a = 5\frac{1}{16}''$. Gently clamp the two rails together and mark the kumiko mortise spacings on their inside surfaces. Similarly, clamp the stiles together and mark the four mortises at intervals of 6".

MARKING THE KUMIKO

Take the four horizontal kumiko in order and turn them so that the X's marking the approximate positions of the first set of half laps are all facing upward. (This will cause the dots marking the fronts of kumiko B and D to face downward.) Allowing ¼" for the kumiko tenons, align the ends of the kumiko with the base of the rail tenon as shown in the diagram. Gently clamp the kumiko to the rail and, using a square, extend the lines marking the mortise cuts on the rails onto the kumiko: these lines indicate where the half laps will be cut. On both ends and along the length of the kumiko, draw lines to indicate the depth of the half lap cuts (half the depth of the kumiko, or ³⁄₁₆"). Mark an X on the ends where wood will be removed to make the kumiko tenons (the shaded area in the drawings).

Follow the same procedure with the vertical kumiko and the stiles.

Before going any further, take the frame and kumiko pieces again and lay them out roughly on your workbench to make sure all the wood is properly indexed.

Now set your marking gauge to ³⁄₁₆" and carefully score the wood between the marks on the rails and stiles to indicate the locations of the kumiko mortises.

Clamp the kumiko to the rails and stiles and extend the lines marking kumiko positions. Allow ¼" for the kumiko tenons. Use a pencil or marking gauge to indicate the depth of the tenons and half laps. Shaded areas indicate where wood will be removed.

MAKING THE KUMIKO MORTISES AND TENONS

Using a narrow butt chisel, make mortises for the kumiko in the rails and stiles to a depth of ¼". Clean out the mortises with a paring chisel. If the mortise is not clean and deep enough the kumiko will tend to bow outward and ruin the flat plane of the lattice.

Clamp the vertical kumiko together, again with the first set of X's marking the half lap cuts facing upward. Saw the two edges of each half lap joint to a depth of ³⁄₁₆" and then pare out and smooth the joints with a chisel. Try to cut precisely, but it is better to undercut than overcut, since you can always make further adjustments later when assembling the pieces.

Now, arrange the kumiko so that the dots marking their front surfaces are all facing the same direction. This should cause the kumiko half laps you have just cut to face alternately up and down. Clamp the kumiko together again and cut the tenons on the ends of the kumiko to a depth of ³⁄₁₆" and a length of ¼".

Similarly, cut the half laps and tenons for the horizontal kumiko.

At this point, to assist you in final assembly, use a light pencil and transfer all the index marks to the insides of the mortises and tenons where they will not show. Now finish plane all the kumiko. This removes the old indexing marks and makes the wood pieces slightly narrower, thus easing the fit of the half laps and mortises. Next, finish plane the rails and stiles. The wood should be inspected, smoothed, and completely cleaned up now, since it can't be effectively worked once all the pieces are together.

One option at this point is to chamfer (bevel at an angle of 45°) the edges of the frame with a plane to soften their lines.

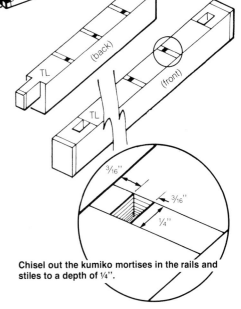

Chisel out the kumiko mortises in the rails and stiles to a depth of ¼".

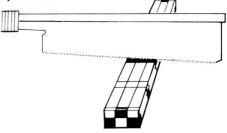

Clamp the kumiko together and saw out the edges of the half laps to a depth of ³⁄₁₆". Then chisel the joint clean.

Turn the kumiko so that the front surfaces are all facing the same direction. This will align the kumiko tenons. Cut these tenons to a depth of ³⁄₁₆". (Figure here distorted for display.)

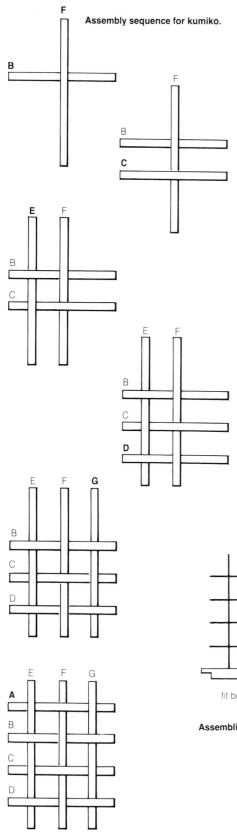

Assembly sequence for kumiko.

Assembly

Assemble the lattice first, one kumiko at a time, weaving from the center to the outside in this order: B, F, C, E, D, G, A. Bend the kumiko slightly as necessary to fit them into position. The half laps should fit together snugly; you can tap them in lightly with a hammer. The wood should compress, but not shear or splinter. You may have to make some adjustment with the plane or chisel. Do so cautiously, removing only a tiny amount of wood at a time. Never try to force the wood to fit, as this will only tear it or cause the lattice to buckle. It is at this point that all your careful measuring has paid off. . . . If one or more pieces don't fit, make new ones and resolve to do better next time.

Now fit the bottom rail mortises onto the vertical kumiko tenons by standing the lattice up and hammering down very lightly on the individual kumiko. Attach the top rail. If you have to hammer on the bottom rail to drive the kumiko into position, place a block over the rail to distribute the force of the hammer and prevent damage to the surface of the wood.

Insert the rail tenons through the stile mortises, at the same time carefully guiding the horizontal kumiko into their mortises.

With the pieces assembled, check the shoji's squareness by measuring the diagonals of the frame. Any remaining gaps between members at this point can be removed by slowly and gingerly tightening clamps around the frame.

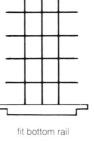

fit bottom rail

Assembling the frame.

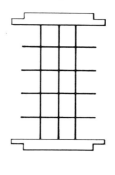

fit top rail

add stiles

Completing the Shoji

Hammer wedges into the saw kerfs you made on the ends of the rails. Wedges can be made of bamboo or any hardwood whose contrasting color will show up nicely against the wood used for the frame. Do not use too much force, and do not drive the wedges farther than halfway into the tenon, or the rail might split. Once the wedges are in place, use a fine-toothed saw to remove the excess lengths of the rails and stiles so that the outside surfaces of the shoji screen are all flush with each other. To prevent injury to the wood, insert a piece of paper between the side of the saw and the wood. Finish up with a fine plane. Plane the endgrains of the stiles toward the rails to prevent wood on the outside edge from splintering off.

Plane all the corners so that the shoji is perfectly square. Any slight deviation from square can be removed by racking or twisting the screen lightly. Note that frames whose members are glued together must be squared before the glue sets up. If you have measured properly, however, the compression fits of all the members will be quite adequate, and you won't need glue.

At this point the frame is complete except for one final detail—balancing the bottom rail for sliding in a wooden track. Plane the bottom surface of the bottom rail so that it is slightly concave ($\frac{1}{16}$" is enough), bowing up in the middle and at track level on both ends. This makes it possible for the screen to move smoothly in the track without rocking. No such treatment is needed for the top rail or if the bottom of the screen is going to be fitted with a wheel, caster, or other tracking device.

An option now is to rabet the tops and bottoms of the rails and stiles for installation into wooden tracks. You can also mortise out a groove in the rail for a Japanese-style door pull. The door pull allows you to open or close the screen without having to grab one of the fragile kumiko or get your fingers close to the delicate white facing.

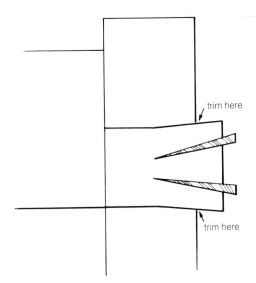

trim here

trim here

Cutaway view of wedges inserted in the rail tenons. Saw off the excess wood until the edge of the tenon is flush with the surface of the stile.

Exaggerated view of a bottom rail planed and balanced.

Door pulls.

Putting on the Face

Your design of the screen should have taken into account the size of the facing material you plan to use. Since traditional Japanese shoji paper often comes in narrow (9¾"–11") widths and is applied horizontally, the horizontal lattice is spaced in such a way that the edges of the sheets always overlap behind a kumiko. Full-width rolls, non-Japanese papers, cloth, plastic, fiberglass, or other materials can be either cut to size or applied over the back of the screen in a single, unbroken sheet.

ATTACHING PAPER

Working with narrow paper sheets is a bit fussier than working with single pieces that can cover the entire shoji in one application. Until you get more practice, the job will probably go easier with a partner.

The illustrations here assume that you have precut all the paper to size for the 24" by 36" screen described on the preceding pages. Each sheet will be applied horizontally, beginning from the bottom of the shoji and working toward the top. Upper sheets will overlap lower ones lap-shingle style to prevent dust from settling in the seams. Japanese paper usually has a rough and a smooth side. It is applied with the smooth side toward the back of the screen.

Attach the paper one sheet at a time as follows. First, make sure the work area and shoji surfaces are clean, dry, and free of dust and bits of debris. Next, prepare the glue (see sidebar). Make sure it is thin enough to apply with a ¼" paintbrush.

Now, on the back of the dry shoji, lay out the first sheet. Check to make sure that the bottom and side edges are exactly parallel to the inner edges of the frame and that the top edge of the paper rests along two-thirds the width of a horizontal kumiko. The paper should extend ⅜" onto the bottom rail. Using a removable cellophane tape, gently fix either the left or right edge of the paper onto a stile to hold it in position.

Carefully lift or roll back the paper—the taped edge stays in place—to expose the wood below. Lightly moisten the wood areas to be glued with a damp cloth. Now apply glue lightly but evenly to all the kumiko and the inner margins of the bottom rail and stiles. Let the

ABOUT GLUE

The facing material is affixed to the back of the shoji with glue. When working with paper, water-soluble glues are best, since at some point the paper will probably have to be removed and replaced, and these glues unbond readily. In Japan, rice glue is frequently used (packaged shoji paper in Japan often comes with its own packet of glue). To make your own rice glue, take half a cup of cooled, cooked rice and mix it with a small amount of water. Using a mortar and pestle, mash it until it is smooth and creamy, a bit like crepe batter. You can also use pastes made of rice starch or corn starch.

Yes Paste is a good commercially available water-soluble glue used in bookbinding. Since it is pH neutral it will not deteriorate the shoji paper over time. Used slightly diluted, it is easily applied with a ¼" paintbrush.

Water-soluble glues do not work well with fiberglass and plastics. For these materials, use so-called white glues or aliphatic glues (yellow glues). These glues are water soluble until they dry. After that, they can be removed only with a lot of scraping. But since fiberglass and plastic sheets needn't be changed very often, the long-lasting nature of these glues shouldn't be a big problem. Acrylic glues work best with Tyvek.

Yes Paste

mortar and pestle

glue sit briefly until it is tacky. Then return the paper to the back of the screen, pulling it tight and making sure that its position is correct.

Trim the paper on the stiles ¼" beyond the margin of the glue with a sharp razor. Be careful not to scratch the wood underneath. Repeat this procedure for the remaining sheets of paper. Overlap the sheets on the kumiko, with lower sheets covering the area two-thirds up from the bottom edge and upper sheets the area two-thirds down from the top edge. When working with patterned paper, align laid marks and other decorative patterns, much as you would do with wallpaper.

When all the sheets of paper are in place, take your razor and straightedge and trim the vertical edges of the paper to a point ⅜" inside the stiles.

Paper has a tendency to sag upon application. Let the shoji sit until the glue is completely dry (at least an hour). Then *lightly* mist them with a gentle fog of clean water from an atomizer to dampen the paper fibers. As the fibers dry they shrink and become taut.

The method for attaching paper that comes in a long and wide roll is similar, except that the paper can be rolled out in a single piece that covers the entire back of the frame. This paper is obviously very convenient and will fit any kumiko arrangement. However, since it is designed for Japanese screens (standard width 35½"), it may be too narrow for most American sizes.

ATTACHING FIBERGLASS OR PLASTIC

When using a single sheet of fiberglass or plastic, cut the sheet somewhat oversize first. As with the paper, fit it into position on the back of the screen, overlapping the frame edges, and fix one end to the frame with tape to hold it in place. Then apply glue to the rails, stiles, and all the kumiko at once. Make sure the glue is even and flat on the wood.

When the sheet is in place, press down at the center and pull all pleats and puckers to the outer edges. The sheet should be perfectly flat against the lattice and frame. Trim it with a sharp razor as necessary to insure that all the edges are straight and parallel to the frame.

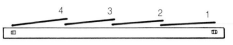

Exaggerated view of how paper overlaps like shingles on the back of a shoji frame.

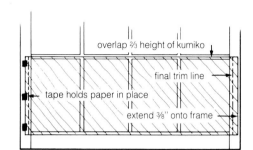

Fit paper into position on back of frame.

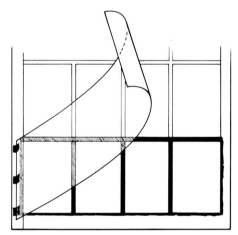

Apply glue to frame with ¼" brush.

Smooth out fiberglass or plastic sheeting from center to edges.

REPAPERING AND RESTORING SHOJI

It is the custom in Japan to replace shoji paper annually as part of the housecleaning at New Year's. While you may not need to repaper your shoji so often, there is much to be said for the way fresh white screens brighten an entire room. But whether you do it annually or not, if you have paper shoji eventually you will have to repaper them to replace faded, dirty, or damaged sheets.

Removing shoji paper—provided you used a starch glue to attach the paper—is easy. Simply sponge the back of the screen with warm water until the paper lifts off. Pull on the paper gently as you go. Small fibers that remain on the wood can be scrubbed off separately. You can even put your screens in the shower or spray them with a hose. Don't let water stand on the wood for any length of time, however.

At antique marts in the United States you can sometimes find old Japanese shoji in need of repair. While these may not be an ideal size, you can always custom-fit an installation to accommodate them. The wood may be old but intact, and often the joinery will be more detailed than what could be obtained today at reasonable cost.

It is sometimes not advisable to try to take an old screen apart to fix or replace broken joints or kumiko. But if the wood is sound and just compressed and loose, dilute some glue and blow it into the recess of the joint with a drinking straw. Clamp the joint and keep it square until the glue sets. Splint, glue, or decoratively tie broken kumiko. If you have to plane and reshape a piece of wood or add new wood to the screen, use mixed watercolors to recreate the patina of the existing pieces.

After the frame and kumiko of an old shoji have been repaired, apply fresh paper using the methods described here.

PAPER PATCHES

Until they have a chance to repaper their screens, Japanese often use paper patches to cover up holes and rips caused by cats, fingers, elbows, and other accidents. Made out of shoji paper scraps, these patches, which create a distinct shadowy area on the other side of the screen, are often cut in decorative flower or snowflake patterns. Making paper shoji patches might be a fun project for children on a rainy day. Here is one example of a patch in the outline of a cosmos blossom.

Fold a perfectly square 6" by 6" paper diagonally in half. Then fold it in half again by bringing point B to point C. Bring each of the two free edges at C upward again to the corner at A so that the paper folds in half once more. Match new vertex D to the cutting pattern here and transfer lines to the folded paper as shown. Cut along the dotted lines with sharp scissors, open up the paper, and there's your patch! Now try inventing your own designs and folding techniques.

To get rid of the folding lines on the patch, lightly mist and iron the paper (use a cloth to protect it) or press it inside the pages of a book, just as you would do with leaves or flowers. Attach the paper to the shoji with a light coat of glue.

Fold a square in half. Then fold B to C.

Open at C and bring each point up to A.

Open paper into flower patch.

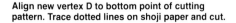

trace and cut here

Align new vertex D to bottom point of cutting pattern. Trace dotted lines on shoji paper and cut.

Shoji lattice patterns can evoke Art Deco or other design genres to match existing Western interiors. Designed by Ed Smalle, Jr. of Crane and Turtle.

FOUR

PROJECTS FOR THE HOME

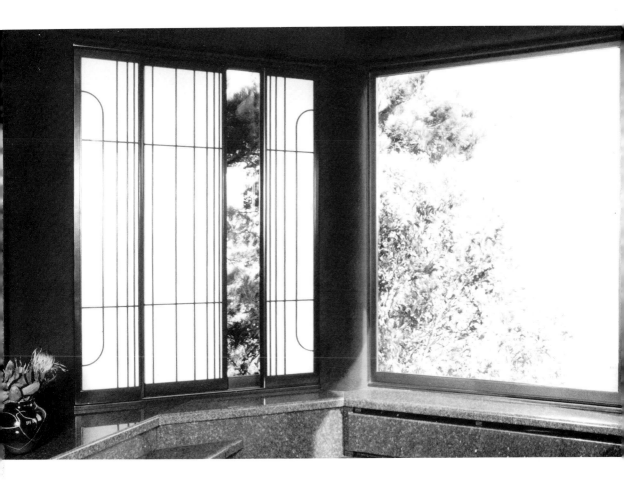

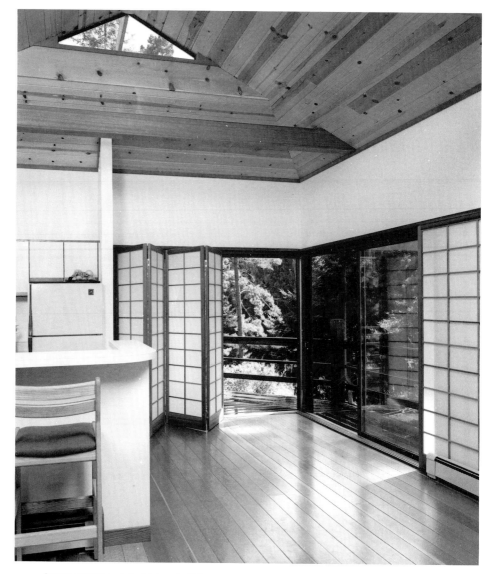

Sliding and hinged shoji (*above*) off the kitchen of the Brockob Residence lead to an outdoor veranda and deck. In the bedroom (*below*), a windowlike shoji is designed to open in its own frame. Shoji by Joseph Elia.

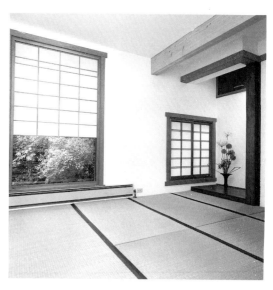

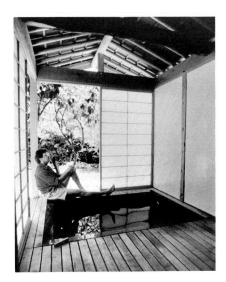

A Japanese-style bathhouse becomes an add-on to a suburban American home. Two of the walls use shoji screens, which open to reveal a view of the garden. U.S.A. Designed and built by David Putnam.

Traditional single-sided shoji are used to carve out a Japanese space from a larger room. Below the table is a *hori-kotatsu*, a pit traditionally filled with charcoal for heating. The shoji can be closed for privacy—the room does double duty as a bedroom—or to keep the heat in. The shoji in the transom at top open to improve circulation. U.S.A. Built by Hiroshi Sakaguchi.

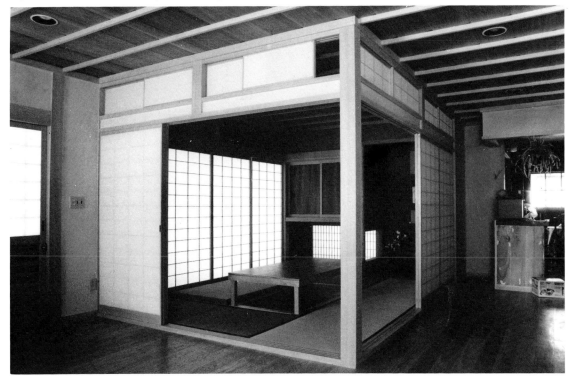

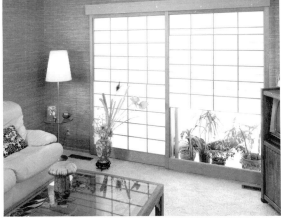

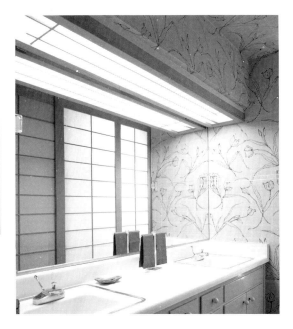

Sliding shoji with windowlike panels are used to precisely control lighting and view, while in the bathroom fiberglass shoji hide a tub and shower and provide diffused lighting above the wash basins. Designed and built by Ted Chase. Lieber Residence, U.S.A.

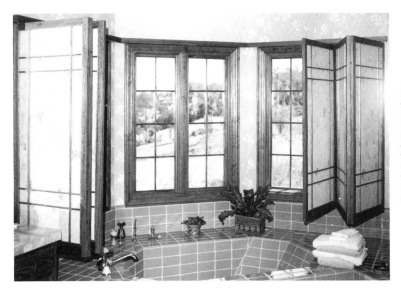

Hinged shoji screens can be used on bay windows or other nonlinear planes unsuited to sliding screens. Here, fiberglass on the window side provides insulation. The inside panels are fitted with hand-batiked fiber to match the wallpaper design. Shoji in a bathroom offer privacy without blocking off natural light. Designed by Max Perlman, Wiseman Lighting and Design. U.S.A.

The strong graphic pattern of the wooden lattice dominates and transforms an ordinary bedroom. Designed by Al Klyce. U.S.A.

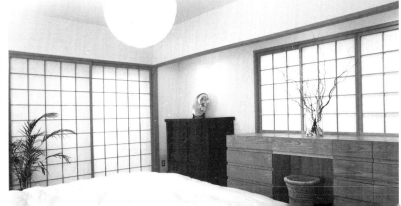

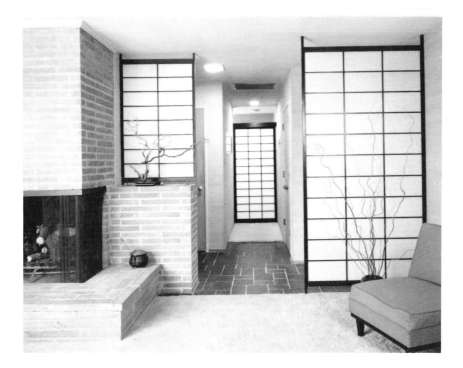

Two views. Fixed shoji screens are used to block off the sight of an entry-way and kitchen from the living room, while a sliding shoji at the end of a hall opens to reveal a decorative scroll or closes to seal off the sleeping area of the house. Currier Residence, U.S.A.

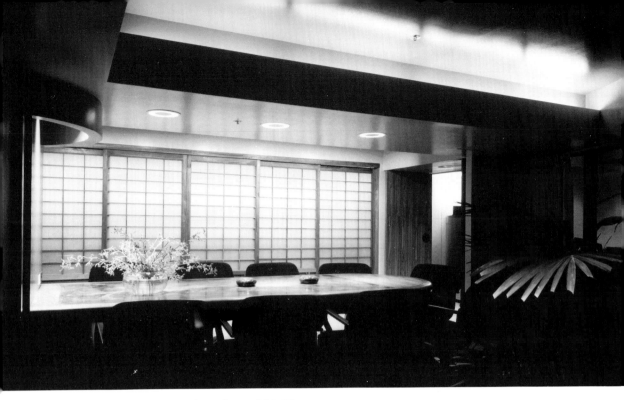

Teak shoji screens around a conference table pro-
vide warmth and light in a business environment.
Shoji in movable tracks offer a range of choices
between open-plan and partitioned workplaces.
Office designed by Gensler and Associates/Archi-
tects for Wilshire Associates, Los Angeles.

Double-sided shoji with sandwiched glass panels
create an airy and bright office environment, with
the additional benefit of soundproofing in the sep-
arate offices. This American company manages
investments in Japan. Shoji built by the author.
Office designed by Parsons Design Group for
G. T. Capital Management, San Francisco.

A single-panel shoji ingeniously controls space in Pardo House "Sticks" by architect Henry Smith-Miller. Instead of sliding, it pivots on a central shaft to accommodate the shifting axes of the building at the same time it acts as a backdrop for the entrance. U.S.A.

As part of his installation "*floating house* DEADMAN" at the University Art Gallery at Amherst, sculptor Peter Shelton used paper shoji, wood framing, and planks to create a baroque visual stew. The outline of the structure is in the shape of the human body, and the entire pavilion is suspended in the air and anchored by counterweights. The diffuse light of the shoji contributes to the "floating" effect.

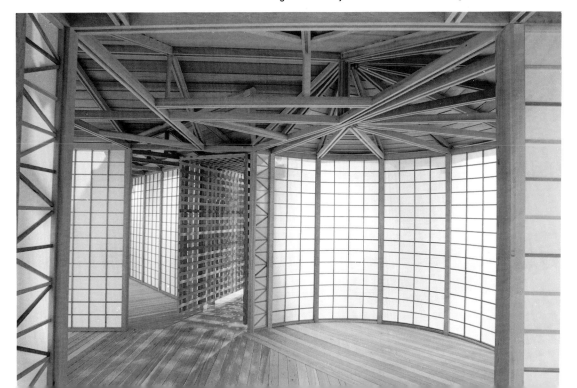

Lattice Patterns

The patterns formed by intersecting kumiko stand out boldly on the white, backlit ground of the shoji screen. Here are examples of lattice patterns that you can use or adapt for your own screens. Like the demonstration shoji in part 3, the kumiko are joined by half laps. (Frame joinery is not shown in these diagrams.) The first group of screens shows full shoji with both simple and complex designs. The second group of screens uses hipboards at the base (see page 78 for construction diagrams). One of the screens here shows an openwork transom at the top. Another has a raised hipboard in the middle with a built-in pull. The third group of screens has windows that can be fitted with glass to present a view of an outdoor landscape even when cold weather doesn't allow you to open the screen itself. The fourth group shows screens with panels that move and open, again to allow a view through the closed screen. The fifth group gives you ideas for how patterns on two or more screens can be combined. The last group shows narrow, decorative screens—*shoin*-style screens—of the sort used in classically elegant Japanese rooms.

Full shoji.

bamboo

Shoji with hipboards.

openwork
transom

woven hipboard

door pull

**Shoji with glass-panel
inserts.**

carved hipboard

Shoji with movable panels.

**Shoji with two-screen
designs.**

Shoin-style shoji.

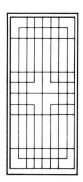

Stationary Panels

A single shoji fitted onto a window or door can dramatically transform an ordinary room. Here are several ideas for how the shoji you made in part 3 might be used by itself (see the following pages for examples of multiscreen installations). First, the screen is simply fitted into a window frame. Four Velcro pads on the corners of the window frame corresponding to Velcro pads on the back of the shoji are enough to hold the screen in place. If the top sash of the window is slightly recessed in the frame, add small blocks in the corners to compensate for the difference in depth. The shoji is easily removed—a good idea if you are renting and don't want a permanent installation. Next, the same screen is slightly modified to hang on hooks in front of a window or on a door. Using a dovetail or wedges where the stiles join the top rail allows the screen to hang without its joints loosening over time. Finally, an insert with a cut-out can be fitted (with Velcro or screws) between an ordinary window frame and the shoji to create an elegant, layered light pattern. Use masonite or plywood for the insert. Make sure the pattern of the cut-out is appropriate to the latticework.

Window insert.

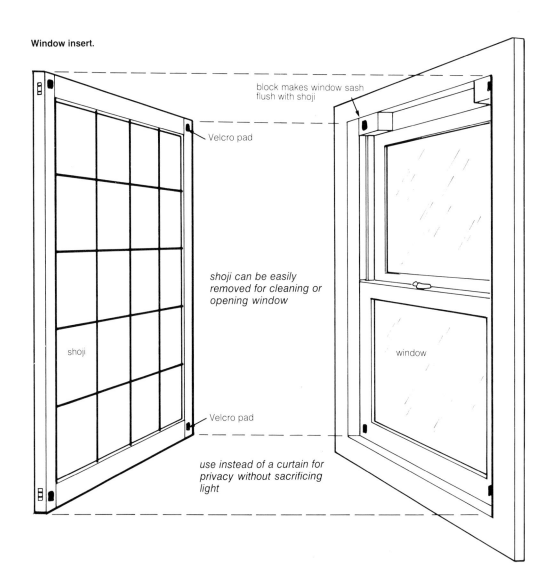

block makes window sash flush with shoji

Velcro pad

shoji can be easily removed for cleaning or opening window

shoji

window

Velcro pad

use instead of a curtain for privacy without sacrificing light

Hanging type.

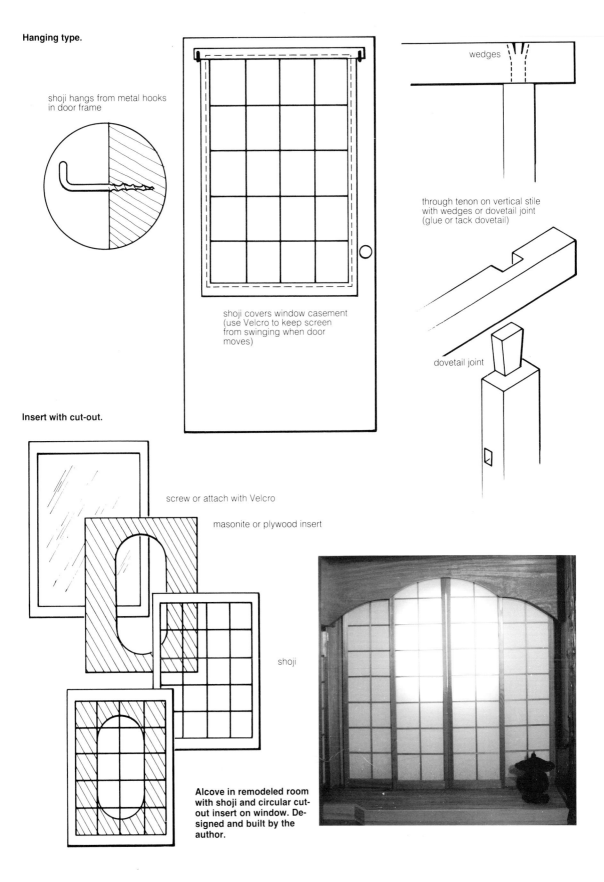

shoji hangs from metal hooks
in door frame

wedges

through tenon on vertical stile
with wedges or dovetail joint
(glue or tack dovetail)

shoji covers window casement
(use Velcro to keep screen
from swinging when door
moves)

dovetail joint

Insert with cut-out.

screw or attach with Velcro

masonite or plywood insert

shoji

**Alcove in remodeled room
with shoji and circular cut-
out insert on window. De-
signed and built by the
author.**

Liner Boxes

Liner boxes are used when installing two or more movable shoji screens into existing window casements or pass-throughs. Because the typical casement in a Western home is relatively shallow, the box will usually protrude a little into the room. Select wood for the box that goes with your other furnishings and finish it nicely; use nail covers or insert the screws where they won't show. In the casement insert shown here, the joints of the box itself are dovetailed or are finger joints glued together. The area between the box and the casement can be hidden with decorative molding. The shoji themselves need at least ⅛" clearance between them for passage. They can be rabeted at top and bottom; recall that the top track is deeper than the bottom track to permit easy removal. A modified liner box might also be used as a room divider or between the kitchen and dining area in a studio apartment. A variation of the liner box is the extended track, shown on the opposite page, which fits flush with the interior wall across the window area. This is used when the casement is too shallow for a liner box, or when you want the option of having the view completely unobstructed.

Liner box.

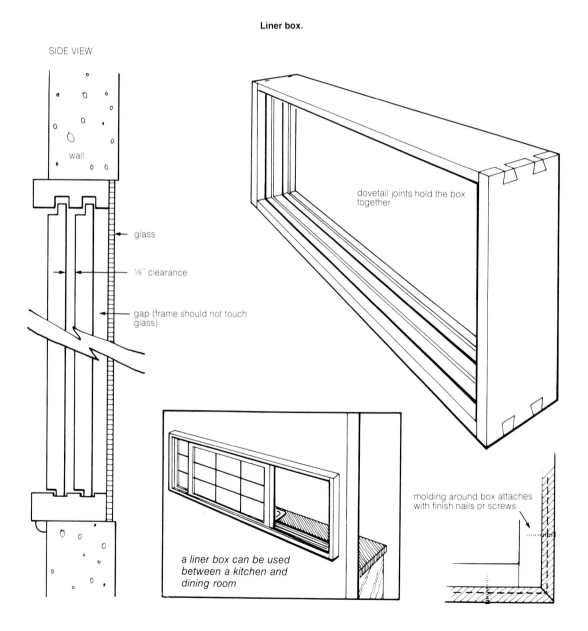

SIDE VIEW

wall

glass

⅛" clearance

gap (frame should not touch glass)

dovetail joints hold the box together

a liner box can be used between a kitchen and dining room

molding around box attaches with finish nails or screws

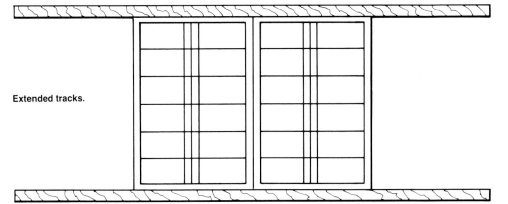

Extended tracks.

CLOSED

OPEN

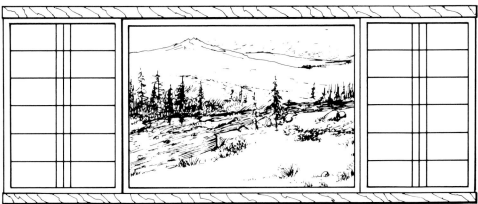

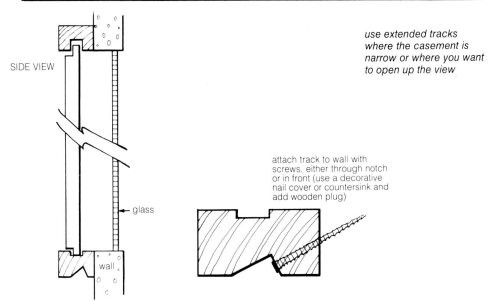

SIDE VIEW

*use extended tracks
where the casement is
narrow or where you want
to open up the view*

← glass

wall

attach track to wall with
screws, either through notch
or in front (use a decorative
nail cover or countersink and
add wooden plug)

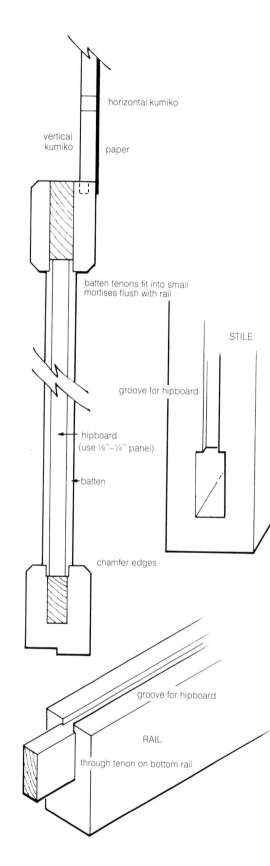

horizontal kumiko

vertical kumiko

paper

batten tenons fit into small mortises flush with rail

STILE

groove for hipboard

hipboard (use ⅛"–¼" panel)

batten

chamfer edges

groove for hipboard

RAIL

through tenon on bottom rail

Hipboards

Hipboards on shoji screens have two functions. First, they act as a structural brace on large screens. Second, they offer protection against vacuum cleaners, cats, feet, and other low-flying objects. If the shoji is used Japanese-style along an exterior veranda or beneath a large overhanging eave, the hipboard will take the brunt of any rain that's blown in. Paper wouldn't survive. Use a hardwood with strong grain patterns for a subtly decorative effect. Battens can be inserted for composition and added strength. The middle rail is joined to the stiles with through tenons.

Sandwich Shoji

In America, where houses are expected to present an attractive face to the neighborhood, double-sided shoji (visible from inside and outside the home) are very popular, while in Japan, where houses are often obscured by high walls, they are rarely used. Two simple lattices are inserted into a frame. The inside screen is glued in place and fitted with the paper. The outer screen is secured by bullet catches or screws for easy removal. By placing the tenon in the middle of the kumiko, you can face the kumiko up or down without worrying about the orientation of the tenon on the end. Clear or frosted glass can be used instead of paper in the sandwich, in which case both screens should be made removable.

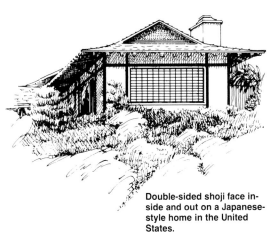

Double-sided shoji face inside and out on a Japanese-style home in the United States.

SIDE VIEW

variation: glue inner shoji to frame

rabet out strip to prevent light leaks

build main frame as described in part 3

bullet catch holds outer screen in place

paper glued to inner shoji

CORNER JOINT FOR SMALL SHOJI

glue

rail

stile

kumiko

cut tenon in center of kumiko

half lap joint

kumiko

through tenon on rail

kumiko

Glass-Panel Shoji

Installing a piece of glass in your shoji frame makes it suitable for an exterior door where security and weatherproofing are a concern. Glass also blocks out sound, making this configuration a good choice for a shoji on a study or bedroom door as well. (See also sandwich shoji, page 79.) A large glass panel is set in a frame with a hipboard. The kumiko lattice—a separate panel backed with paper—is held in the main frame with ¼" bullet catches. Leave a ¼" gap between the glass and the sheeting to prevent condensation from getting on the sheeting and staining or loosening it.

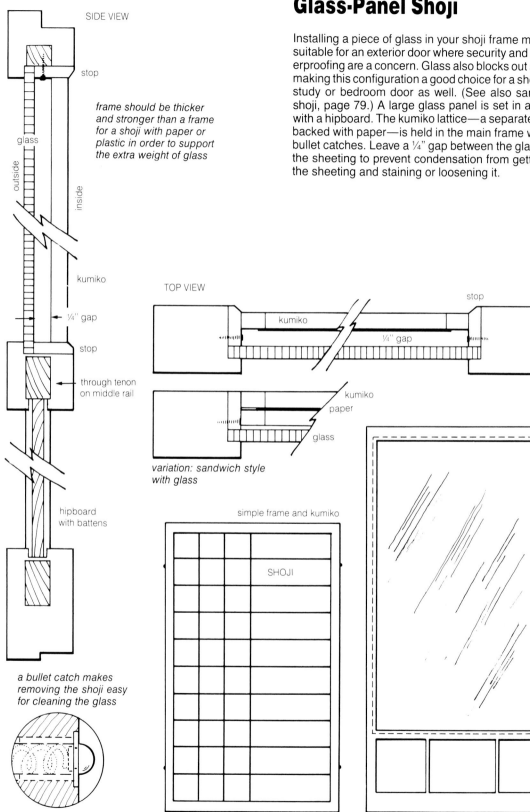

SIDE VIEW

stop

frame should be thicker and stronger than a frame for a shoji with paper or plastic in order to support the extra weight of glass

glass

outside

inside

kumiko

← ¼" gap

stop

through tenon on middle rail

hipboard with battens

a bullet catch makes removing the shoji easy for cleaning the glass

TOP VIEW

kumiko

¼" gap

stop

kumiko

paper

glass

variation: sandwich style with glass

simple frame and kumiko

SHOJI

Closets, Cabinets

Turn your closet into an attractive piece of furniture in the bedroom by installing shoji screens. A soft fluorescent tube or a low-wattage bulb inside the closet will illuminate the screens from behind and serve as an indirect light source for the room. Instead of cutting tracks in the floor, you can tack or glue in raised ¼" ridges of ⅛" hardwood that fit in grooves in the shoji rails. A similar idea can be applied to cabinets or bookshelves. If the shelving is to be custom-made, shallow grooved tracks for the shoji are obviously much more practical. A narrower, fixed screen, hinged at one side, would look good on a broom closet or pantry.

Cabinet.

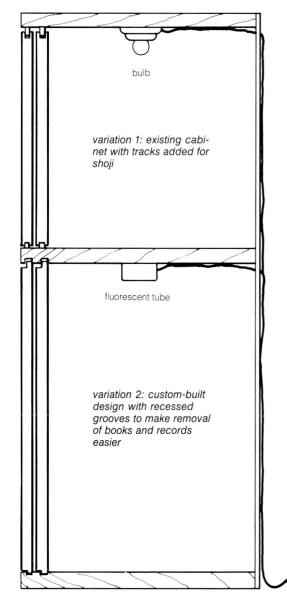

bulb

variation 1: existing cabinet with tracks added for shoji

fluorescent tube

variation 2: custom-built design with recessed grooves to make removal of books and records easier

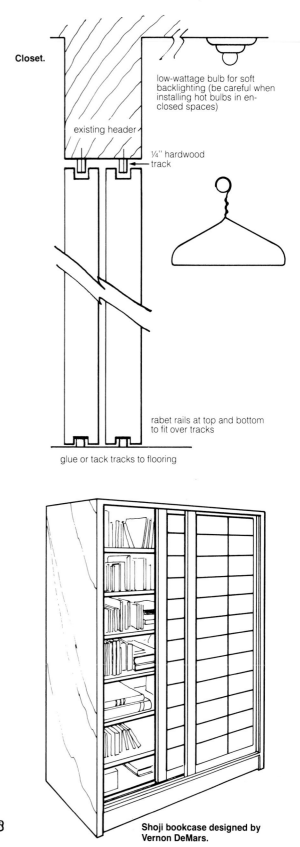

Closet.

low-wattage bulb for soft backlighting (be careful when installing hot bulbs in enclosed spaces)

existing header

¼" hardwood track

rabet rails at top and bottom to fit over tracks

glue or tack tracks to flooring

Shoji bookcase designed by Vernon DeMars.

Shoji with Movable Panels

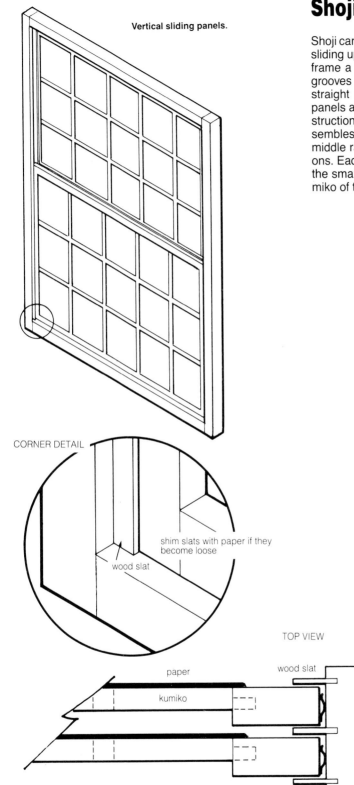

Vertical sliding panels.

Shoji can be built like windows, with one or both panels sliding up and down to let in more light or breeze or to frame a view. Removable narrow slats are fitted into grooves in the stiles. These keep the sliding panels straight and prevent light leaks from the sides. The panels are held in place by spring clips. Another construction has the panels moving horizontally and resembles the liner box described on page 76. Two middle rails are joined to the frame with through tenons. Each middle rail is grooved and mortised to hold the small, movable kumiko lattice panels and the kumiko of the main screen.

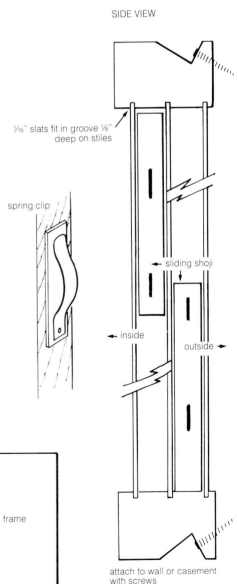

SIDE VIEW

1/16" slats fit in groove 1/8" deep on stiles

spring clip

sliding shoji

inside

outside

attach to wall or casement with screws

CORNER DETAIL

shim slats with paper if they become loose

wood slat

TOP VIEW

paper

wood slat

kumiko

frame

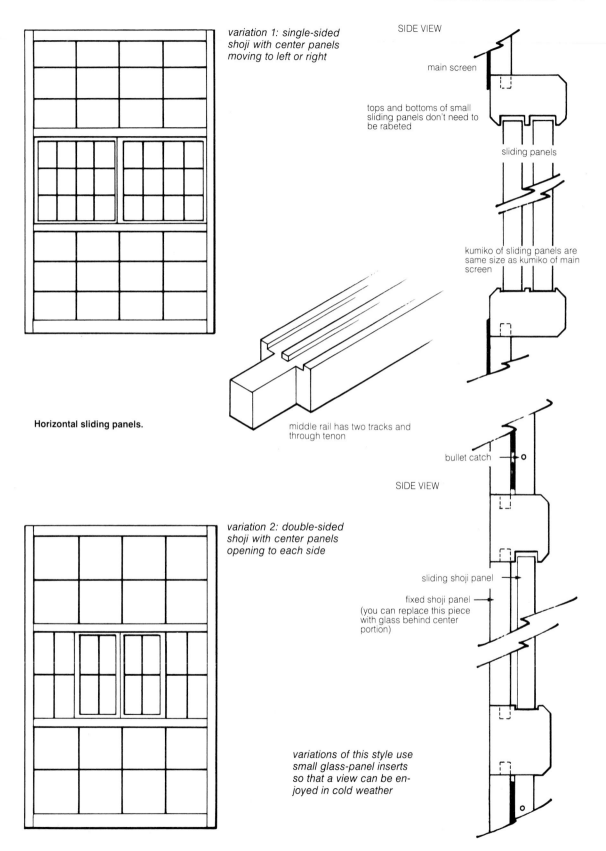

variation 1: single-sided shoji with center panels moving to left or right

SIDE VIEW

main screen

tops and bottoms of small sliding panels don't need to be rabeted

sliding panels

kumiko of sliding panels are same size as kumiko of main screen

Horizontal sliding panels.

middle rail has two tracks and through tenon

bullet catch

SIDE VIEW

variation 2: double-sided shoji with center panels opening to each side

sliding shoji panel

fixed shoji panel
(you can replace this piece with glass behind center portion)

variations of this style use small glass-panel inserts so that a view can be enjoyed in cold weather

Valances, Hanging Screens

Tall Japanese shoji generally run in tracks recessed unobtrusively into the flooring of the home. Of course these tracks are built into the home from the very beginning. In American homes, however, shoji are often installed as an afterthought, to serve a particular need that was not first apparent to the architect or client. Most people don't want to tear up their floorboards to install Japanese-style recessed tracks, particularly if they have carpets. One solution for patio doors and pass-throughs within the home, then, is to hang the screens so they're not touching the floor at all. There are many types of tracking hardware available, and you must be sure to design your screen around the hardware manufacturer's recommended loads and dimensions. Hide the tracking mechanisms with a valance. Hinged installations enable you to open up the pass-through completely, a good idea if there is a lot of traffic in the room. A valance won't work with hinged screens, but you can hide the metal tracks by inlaying them into a strip of hardwood screwed to the top of the doorframe. No tracking guides are needed at the bottom of the screen. Use unobtrusive hinges; check with your local hardware store for hinge varieties and installation guides.

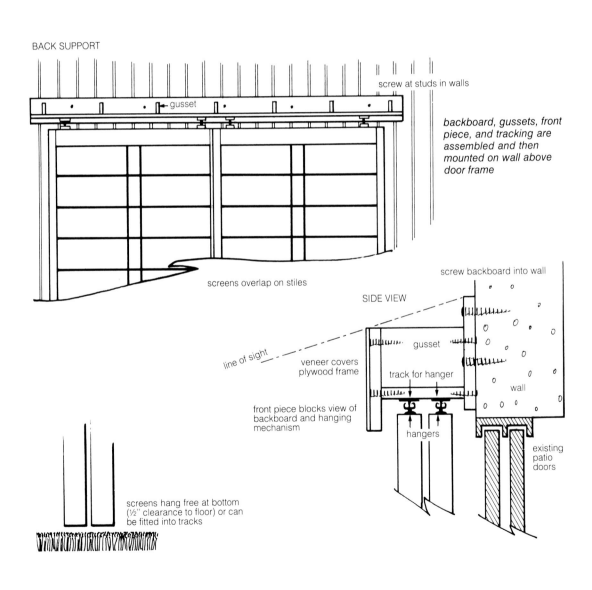

BACK SUPPORT

screw at studs in walls

gusset

backboard, gussets, front piece, and tracking are assembled and then mounted on wall above door frame

screens overlap on stiles

SIDE VIEW

screw backboard into wall

line of sight

veneer covers plywood frame

gusset

track for hanger

wall

front piece blocks view of backboard and hanging mechanism

hangers

existing patio doors

screens hang free at bottom (½" clearance to floor) or can be fitted into tracks

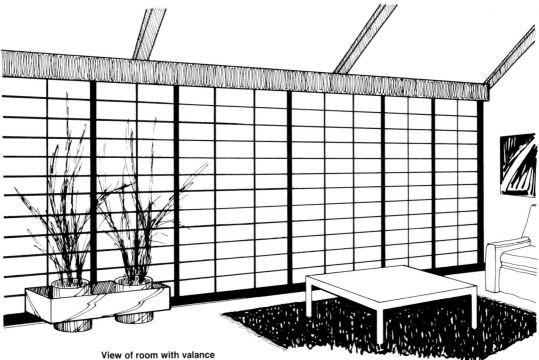

View of room with valance and shoji installed on southern exposure.

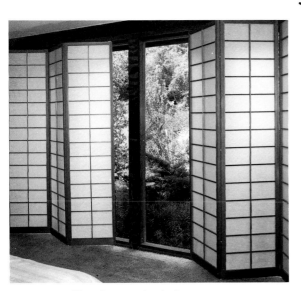

Hinged screens in a bedroom. Designed by Crockett Design House.

hinged installations use pins and swivel hangers; the track is hidden by inlaying it in the door frame

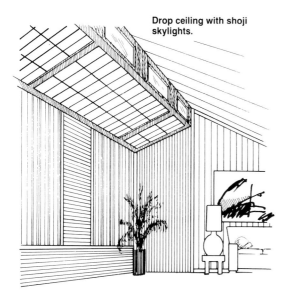

Drop ceiling with shoji skylights.

Ceiling Fixtures, Skylights

An existing light fixture can be dressed up by fitting it with a shoji and wooden frame. In the example here, based on a design by woodworker Ted Chase (see page 66), both the shoji panel and box are fitted with magnetic catches to make bulb replacement easy. Use fluorescent tubes or a row of low-wattage incandescent bulbs set back from the front panel, which can be of a fire-resistant material like white acrylic plastic or fiberglass. On an existing lightwell or skylight, install a support frame and then angle and lift the shoji onto it. A dropped ceiling with shoji in a corner of a room makes an attractive tokonoma-style alcove.

Ceiling fixture.

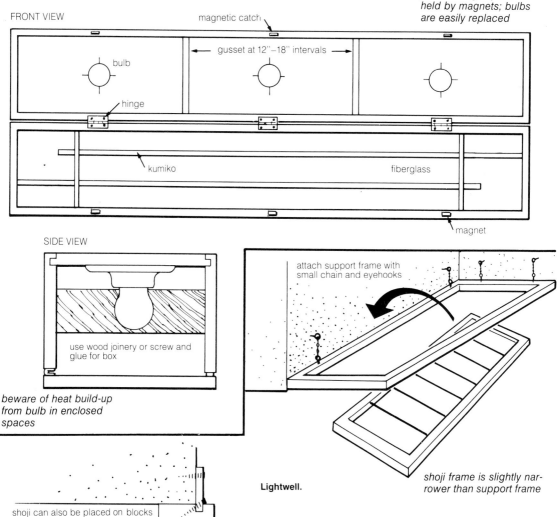

panel swings up and is held by magnets; bulbs are easily replaced

FRONT VIEW

magnetic catch

gusset at 12"–18" intervals

bulb

hinge

kumiko

fiberglass

magnet

SIDE VIEW

use wood joinery or screw and glue for box

beware of heat build-up from bulb in enclosed spaces

attach support frame with small chain and eyehooks

Lightwell.

shoji frame is slightly narrower than support frame

shoji can also be placed on blocks

Decorative Wall Boxes

Shoji can be incorporated into the home in many ways. Here, designer Kiyoto Onogi of Stanley, Kansas, has made a cabinet door and a large-scale panel using a shoji lattice with live tree branches and leaves and artificial flowers. These panels can be fitted into a wall or placed in front of a window. They can be backlit and hung like a painting. Or, if built to be viewed from both sides and placed in a stand, they can be used as room dividers. It might be possible to change the arrangement according to the season, but Onogi doesn't advise that; he says it takes enough work to get even one design to come out looking right.

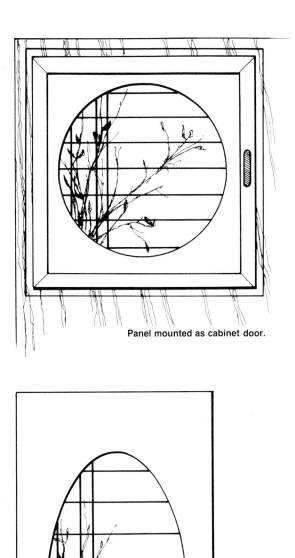

Panel mounted as cabinet door.

box can be backlit with low-wattage bulb

paper attaches to back of rear panel

rear panel

lattice attaches to inside of rear panel with glue or small nails

branches, dried flowers, and leaves attach to lattice with wooden nails and glue

kumiko

front panel

¼" plywood panel

front and rear panels form a sandwich over shoji lattice

Lanterns

Lanterns are an essential part of Japanese tea gardens, where they are used to light the path of guests as they make their way to the tea-ceremony room. Fitted with shoji, a lantern (using electricity or candles) can be placed in your garden, on the border of a patio, in a corner of a room, or, stripped of its base, hung from the ceiling or attached to a wall. Use hinges on at least one face of the lantern so that you can open it to change the bulb or candle. Use low-wattage bulbs to avoid overheating. A precisely made shoji atop a base of rough-natural stone offers an interesting contrast in shapes and textures.

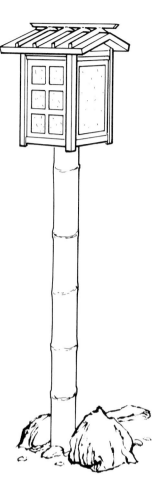

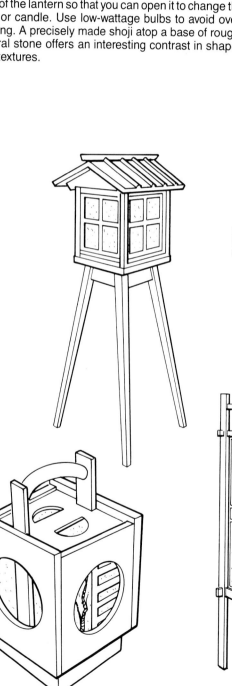

Line drawings based on lantern designs by Kiyoto Onogi.

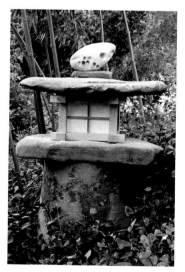

Lantern of natural stone and shoji designed by Karen Ehrhardt and the author.

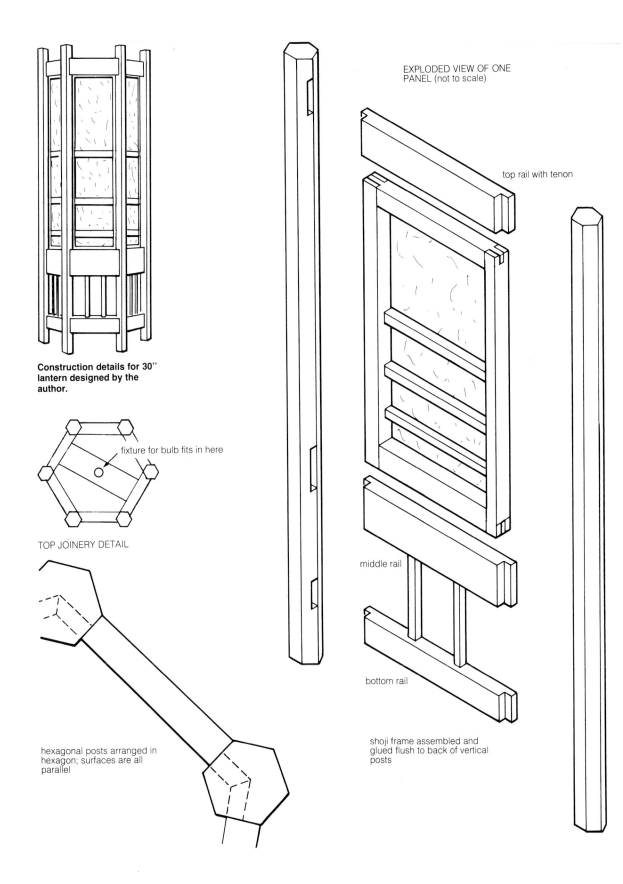

**Construction details for 30"
lantern designed by the
author.**

fixture for bulb fits in here

TOP JOINERY DETAIL

hexagonal posts arranged in
hexagon; surfaces are all
parallel

EXPLODED VIEW OF ONE
PANEL (not to scale)

top rail with tenon

middle rail

bottom rail

shoji frame assembled and
glued flush to back of vertical
posts

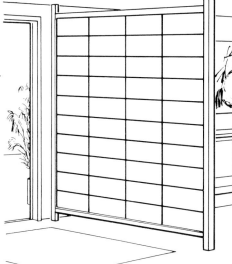

A shoji used as a room divider to separate a living room from a kitchen.

Freestanding Screens

Hide an entryway or divide a room with freestanding screens. Two or more hinged panels will stand alone. You can also make decorative bases to hold single panels. If the installation is permanent, design a screen whose frame can be attached to the wall or ceiling. These screens are good for creating quiet corners in the home with visual privacy but without loss of light or expensive remodeling. In larger rooms or at parties, they can be moved around Japanese-style to suit the needs of the moment, easing traffic flow or hiding a serving area.

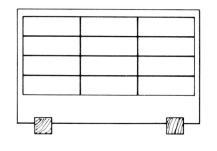

Two-panel hinged screen.

Stands.

tacked-on paper or cloth strips can be used as a flexible hinge

Three-panel hinged screen designs.

Outdoor Shoji

Similar to freestanding screens, shoji outdoors can be used for visual privacy without major loss of light. Fiberglass or rigid plastic should be used for the facing; check with your supplier to make sure the material won't degrade in sunlight. Use cedar, redwood, or some other insect- and water-resistant wood for the frame. The fence on this page was designed by the author to block the view of the neighbor's entryway where local codes prohibited making the existing fence taller. Support rafters extended from the house to the top of the fence form a trellis.

Simple joinery.

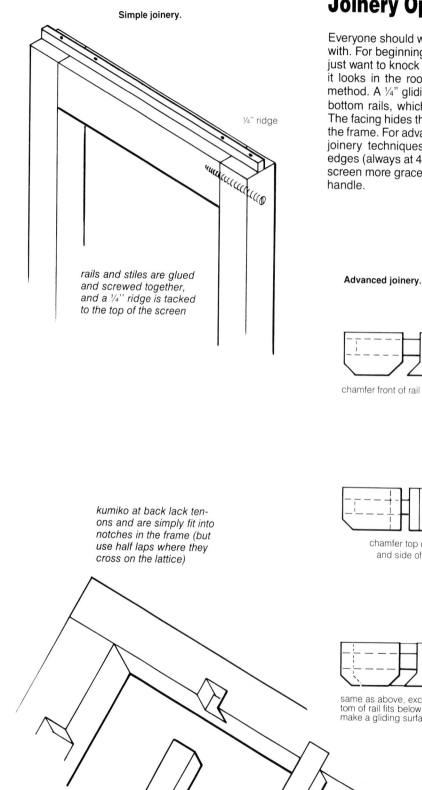

¼" ridge

rails and stiles are glued and screwed together, and a ¼" ridge is tacked to the top of the screen

kumiko at back lack tenons and are simply fit into notches in the frame (but use half laps where they cross on the lattice)

Joinery Options

Everyone should work at a level they feel comfortable with. For beginning woodworkers—or for people who just want to knock a shoji together quickly to see how it looks in the room—here is a simple construction method. A ¼" gliding ridge is nailed onto the top and bottom rails, which are glued and screwed together. The facing hides the joints where the kumiko attach to the frame. For advanced woodworkers, here are some joinery techniques for the framing. Chamfering the edges (always at 45°) of the rails and stiles makes the screen more graceful to the eye and more pleasant to handle.

Advanced joinery.

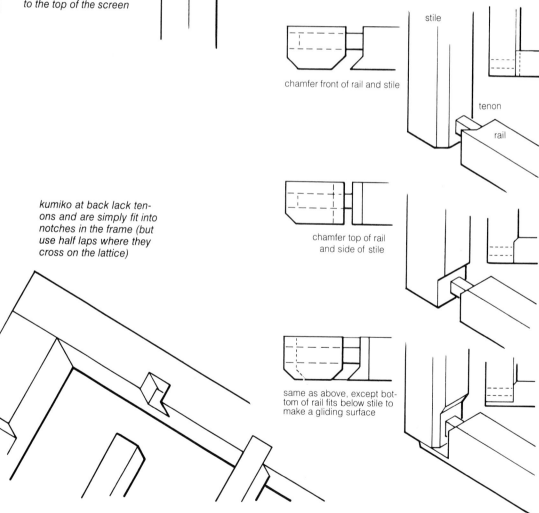

stile

chamfer front of rail and stile

tenon

rail

chamfer top of rail and side of stile

same as above, except bottom of rail fits below stile to make a gliding surface

A false ceiling with shoji creates an elegant low entryway that functions as a transition zone to the higher-ceilinged room beyond. The door has been fitted with veneer to match the interior decor. Designed and built by the author.

APPENDIX

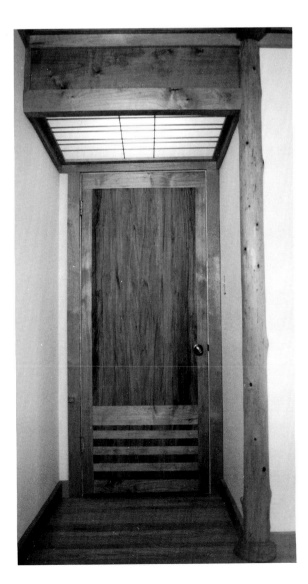

Security

Large sliding wooden doors called *amado* were used on old-style Japanese houses to protect the delicate shoji screens from inclement weather and to secure the home from thieves and vandals. These doors moved in tracks on the outside of the window or veranda. When not in use they were stacked in sleeves just beyond the pass-through. *Amado* were very heavy and blocked off light from the interior of the home. They were essential, however, because paper shoji were so defenseless.

Today, with modern sheetings available, security can be obtained without sacrificing airiness. The best approach is to install a panel of ¼" safety glass on the outside of the screen, with a single- or double-sided lattice on the inside. Use a thick frame and be sure to fit the glass in from the inside so that it can't be easily removed from the outside. Leave at least a ¼" gap between the facing material and the glass to avoid the paper or plastic being affected by condensation (see part 4, p. 80).

Locks designed for sliding doors like patio doors are available in hardware stores and can generally be fitted into shoji screens. The Japanese-style lock shown here is designed to be used where stiles overlap each other. It is sturdy enough but lacks a key for unlocking from the outside. It might be used in combination with a larger, key-operated device or to pull adjoining screens tightly together to eliminate drafts.

Books on Japanese Tools and Woodworking

Hayashi, Masako, ed. *Shoji no hon* [The book of shoji]. In Japanese. Tokyo: Molza, 1978.

Lanz, Henry. *Japanese Woodworking Tools: Selection, Care, and Use*. New York: Sterling, 1985.

Morse, Edward S. *Japanese Homes and Their Surroundings*. 1886. Reprint. New York: Dover, 1961.

Nakahara, Yasuo. *Japanese Joinery: A Handbook for Joiners and Carpenters*. Point Roberts, WA: Hartley and Marks, 1983.

Odate, Toshio. "Japanese Sliding Doors: The Traditional Way to Make *Shoji*." In *Fine Woodworking on Joinery*. Newtown, CO: Taunton Press, 1985.

———. *Japanese Woodworking Tools: Their Tradition, Spirit, and Use*. Newtown, CO: Taunton Press, 1984.

Sato, Hideo. *Japanese Woodworking: A Handbook of Japanese Tool Use and Woodworking Techniques*. Point Roberts, WA: Hartley and Marks, 1987.

Seike, Kiyoshi. *The Art of Japanese Joinery*. Tokyo: Weatherhill/Tankosha, 1977.

Yagi, Koji. *A Japanese Touch for Your Home*. Tokyo: Kodansha International, 1982.

Yanagi, Soetsu. *The Unknown Craftsman: A Japanese Insight into Beauty*. Foreword by Shoji Hamada. Tokyo: Kodansha International, 1972.

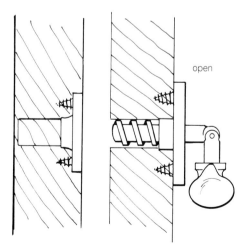

open

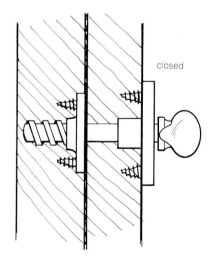

closed

Paper Vendors

Aiko's Art Materials Import
714 North Wabash Avenue
Chicago, IL 60611
312-943-0745

Amsterdam Art
1013 University Avenue
Berkeley, CA 94710
415-548-9663

Cando K. Hoshino
1541 Clement Street
San Francisco, CA 94710
415-752-1636

Elica's Paper
1801 Fourth Street
Berkeley, CA 94710
415-845-9530

Harvard Square Art Center
17 Holyoke Street
Cambridge, MA 02138
617-491-3883

Kabuki Gifts and Imports
11355 Santa Monica Boulevard
West Los Angeles, CA 90025
213-477-2663

Karel Art Materials
737 Canal Street
Stamford, CO 06902
203-348-8996

Kasuri Dyeworks
1959 Shattuck Avenue
Berkeley, CA 94704
415-841-4509

New York Central Art Supply
62 Third Avenue
New York, NY 10003
212-473-7705

Warlon K.K.
7-21 Chihara-cho
Nakamura-ku
Nagoya, Japan 453
052-451-1456

Tool Vendors

Many of these vendors provide instructive catalogs on Japanese tools for mail-order customers. Write or phone for further information.

Aqua Sharpening Stone and Tools
1129 Solano Avenue
Albany, CA 94706
415-525-8948

Hida Japanese Tool
1333 San Pablo Avenue
Berkeley, CA 94702
415-524-3700

Highland Hardware
1945 North Highland Avenue NE
Atlanta, GA 30306
404-872-4466

Tashiro Japanese Tools
1435 South Jackson Street
Seattle, WA 98144
206-322-2671

The Japan Woodworker
1731 Clement Avenue
Alameda, CA 94501
800-537-7820

The Luthierie
2449 West Saugerties Road
Saugerties, NY 12477
914-246-5207

The Wood Works
14007 Midland Road
Poway, CA 92064
619-748-4363

Index

aesthetics, 18–19, 25, 46
amado, 18, 19, 94
architecture, Japanese, 18, 19, 20
architecture, Western, 18, 20
artificial polishing stones, 40, 41, 44
assembly, 58
awase finishing stones, 41

balancing bottom rail, 59
bifold (hinged) shoji, 18, 19, 27, 46, 85
blind mortise, 54
blue stones, 41
burnishing the wood, 19, 35

capturing the view, 19, 70, 77, 82
carpenter's square, 30–31, 50
cedar, 20, 22, 91
ceiling fixtures, 86
chamfering, 57, 92
chisel blades, 43; polishing, 43–44
chisels, 28, 29, 31–33
closets and cabinets, 25, 81
custom shoji, 19
cypress, 20, 22

design considerations, 19, 20, 24, 26–27, 46–47
dimensions of shoji, 21, 26, 46, 48–49
door pulls, 59
dozuki saw, 29, 38

extended tracks, 77

factory-made shoji, 19
fiberglass, 25, 47, 60, 86; attaching, 61
finishing stones, 41, 44
finish planing, 19, 35, 59
frame construction, 51–53
freestanding shoji, 18, 27, 90
fusuma, 18

glass, 21, 25, 27, 79, 80, 94
glass-panel shoji, 47, 70, 80, 94
glue, 20, 60

half laps, 54, 57
hammers, 28, 29, 31
handmade shoji, 19
hanging shoji, 27, 46, 84–85. *See also* valance
hardwood, 20, 59, 78
hinged shoji. *See* bifold shoji
hinges, 84, 90
hipboards, 21, 27, 47, 70, 78
"Honyama" finishing stones, 41

indexing, 30, 51, 52, 55
inspecting wood, 50, 57
installations, 19, 25, 26–27, 46, 48, 49
insulation, 19, 25

integration of home with nature, 19, 77

Japanese tools, 28–29, 30–44
joinery, 18, 20, 28, 47, 92

kumiko construction, 18, 54–57
kumiko designs, 24, 47, 54, 70–73
kumiko mortise, 33, 57
kumiko weaving, 54, 55

lanterns, 88–89
lattice patterns. *See* kumiko designs
layout tools, 29, 30–31
light, 18, 19, 27
lighting elements, 81, 86, 88–89
liner boxes, 48, 76–77
locks, 94

machine-made shoji, 19
machine tools, 28
marking gauges, 31
medium polishing stones, 41, 44
mortise, 52, 54; cutting, 32–33, 51, 52–53; for kumiko, 33, 57
movable panels, 47, 70, 82–83
multiscreen installations, 26

natural polishing stones, 40, 41, 42
nontraditional uses of shoji, 18, 19, 25, 79

opening out of plumb, 46, 48
outdoor shoji, 25, 91

paper, 18, 24–25, 47; attaching, 60–61
paper patches, 62
plane blades, 36; polishing, 43–44
plane blocks, conditioning, 37
planes, 28, 29, 32, 35–38, 46–47
plane sub-blade, 37, 38
plastic, 21, 25, 27, 60, 86; attaching, 61
polishing stones, 28, 29, 40–44
polishing techniques, 40, 41–44
Port Orford cedar, 20, 22
privacy, 19, 27, 80
purchasing shoji, 19

rabeting the rails, 26, 59, 76
repapering shoji, 24, 62
restoring shoji, 62
rice glue, 60
"rice" paper, 24, 60
rollers, 27
roll paper, 24, 60, 61
rough polishing stones, 40–41, 42, 44
ryoba saws, 29, 38

sanding, 19, 35
sandwich shoji, 18, 47, 79
saws, 28, 29, 38–39
scabbard for chisel, 34
screw fastenings, 20, 92
security, 19, 80, 94

skylights, 86
sliding shoji, 19, 26–27, 46
softwood, 20
space, perceptions and use of, 18, 26, 90
specialty chisels, 29, 31
staining, 19, 47
stationary panels, 74–75
structural considerations, 21, 26, 27, 46
sumi ink, 30, 36
sumisashi, 30
sumitsubo, 30
Synskin, 25

tenon, 48, 52, 54; cutting, 38–39, 51, 52–53
tokonoma, 86
tracking systems, 19, 26, 27, 46, 48, 76–77, 81, 84–85
Tyvek, 25, 60

valance, 27, 84–85

wall boxes, 87
washi, 24, 60
wedges in tenon, 47, 53, 59
Western tools, 28, 29, 38
window inserts, 74, 75
wood, 20–21, 35, 38, 46–47, 48, 49, 50; varieties, 22–23
"working length," 51, 52

Japanese garden lantern refitted with shoji by the author.